IMAGES
of America

OCEAN GROVE

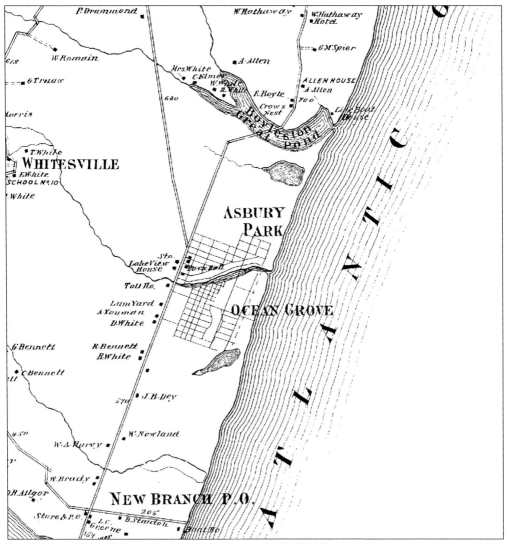

The Ocean Grove Camp Meeting Association (OGCMA) is located on the northern New Jersey coast in Monmouth County. After the Civil War, many small seashore communities were created as the result of speculative land development. Successful communities would petition their state legislatures for a charter to incorporate as a separate local governing body. The large land townships that comprised Monmouth County were gradually reduced in size. The heritage of Neptune Township and Ocean Grove can be traced to 1849 when the township of Ocean was subdivided from the township of Shrewsbury. Ocean Grove was part of Ocean Township when it received its charter from the State of New Jersey as a Camp Meeting Association in 1870. Neptune Township was chartered by the State of New Jersey on February 26, 1879. The boundaries of Neptune Township included the more than 350 acres of the OGCMA. Later, other communities would petition the state legislature to become local legislative bodies. Neptune Township formerly included Asbury Park, Bradley Beach, Avon, and Neptune City. The F.W. Beers atlas of 1873 details the initial street outline for both Ocean Grove and Asbury Park. The blank areas in the center of Ocean Grove are coastal dunes, the Camp Ground, Carvosso Lake, and Ocean Pathway. A lumber supply yard and turnpike tollhouse are south of the Wesley Lake stream crossing. (Historical Society of Ocean Grove.)

IMAGES of America
OCEAN GROVE

Wayne T. Bell

Copyright © 2000 by Wayne T. Bell
ISBN 978-0-7385-0425-4

Published by Arcadia Publishing
Charleston SC, Chicago IL, Portsmouth NH, San Francisco CA

Printed in the United States of America

Library of Congress Catalog Card Number: 00102556

For all general information contact Arcadia Publishing at:
Telephone 843-853-2070
Fax 843-853-0044
E-mail sales@arcadiapublishing.com
For customer service and orders:
Toll-Free 1-888-313-2665

Visit us on the Internet at www.arcadiapublishing.com

ACKNOWLEDGMENTS

This book is dedicated to my wife, Shirley, who is a fourth-generation Ocean Grover, and to our four daughters, Wendi, Lynn, Cindy, and Sharon, all of whom grew up in Ocean Grove and now bring their families and friends to the Grove for the summer Camp Meeting.

No book is ever produced without support from others. In Ocean Grove, there are always individuals who freely give of their time and share their personal information of the past. This is one of the reasons why Ocean Grove is a caring community with its unique history and an ever-emerging future. Credit must be given to the late Jack Steinberg, first curator of the Historical Society of Ocean Grove, and to Neptune Township's historian, Peggy Goodrich, both of whom initiated so much interest in our local history.

This book could never have been accomplished without Ray Smith, who performed magic on his computer in the reproduction of 218 photographs. Thanks to Shirley Bell, who typed all the words; to Bill Kresge for his factual editing of the manuscript; to Barbara VanDuyne, Cindy Bell, Judy Kaslow, and Derek Parish for caption review; to Judy Ryerson, Jim Lindemuth, Ethel Hemphill, the Historical Society of Ocean Grove, and the Neptune Museum for providing photographs and other Ocean Grove material; to Phil May, president of the Historical Society of Ocean Grove; and to William Jeremiah, Esq. Thanks also to many others who contributed: Betty Brown, Herman Brown, Eva Cadmus, Janet Davison, Janet Hendrickson, Helen Hurry, Phyllis Keutgen, Joyce Klepper, Evelyn Stryker Lewis, Virginia Long, George Moss, Robert Nilson, Herb Noack, Irma Norman, Marilyn Pfaltz, Betty Polhemus, Thelma Rainear, Martha Rakita, Phyllis Schroeder, Mary Jane Schwartz, William Schwartz, Howard Smith, Robin Smith, Leonard Steen, Steven Weilert, Winnie and Lee Wooding, and Bill Zimmerman. The author takes credit for any errors or omissions.

Contents

Acknowledgments		4
Introduction		7
1.	Beginnings	9
2.	From Tents to Cottages	25
3.	Auditorium Square	41
4.	Changing Scenes	55
5.	Grand Hotels	73
6.	Boardwalk-by-the-Sea	89
7.	Memories and Memorials	105
Bibliography		128

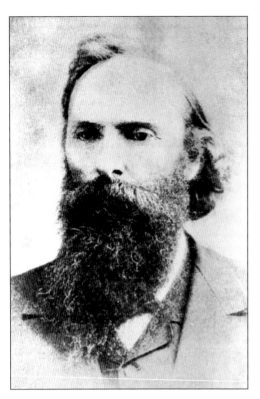

Rev. William B. Osborn (1832–1902) was the son of an itinerant Methodist preacher. His religious conversion at a Camp Meeting in 1857 awakened him to his life's work of evangelism in a Camp Meeting setting. He was the founder of Ocean Grove. As superintendent, Osborn secured Ocean Grove Camp Meeting Association approval for the design of Ocean Pathway—a 1,500-foot-long vista widening from 200 feet to 300 feet as it moved from the Auditorium to the sea. Osborn resigned the superintendent's position in 1872 to do missionary work elsewhere.

Over the years, Osborn founded 11 other permanent religious resorts and helped to originate 30 Camp Meetings. His missionary zeal was worldwide as he established the first Camp Meetings in India at Lanowli and in Ocean Grove, Australia. On July 15, 1873, Osborn was presented with a handsome cottage at the corner of Pilgrim Pathway and Lake Avenue. His friends had raised over $3,000 for this token of their esteem for Osborn. (Historical Society of Ocean Grove.)

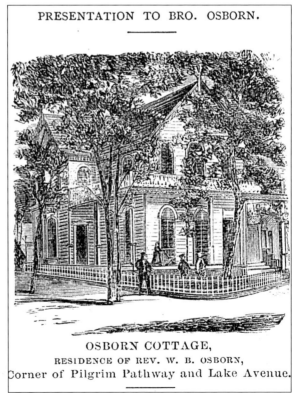

PRESENTATION TO BRO. OSBORN.

OSBORN COTTAGE,
RESIDENCE OF REV. W. B. OSBORN,
Corner of Pilgrim Pathway and Lake Avenue.

INTRODUCTION

The historic district of Ocean Grove, located in Neptune Township on the northern New Jersey coast in Monmouth County, is an example of an old Camp Meeting ground. Camp Meetings and religious revivals are as American as apple pie. Camp Meeting lineage can be traced to the Great Religious Revival period (1781–1805) that began on what was then the southern frontier of Georgia and the Carolinas. One religious Camp Meeting in 1801 involved some 3,000 to 5,000 people traveling to a farmer's field and woods near Cane Ridge, Kentucky. The four- to five-day outdoor revival featured ministers preaching from rustic planked platforms and freshly cut tree stumps, leading their flocks both night and day with sermons on sin and atonement. The emotionally exhausted worshipers would retire to their covered wagons and tents for rest, only to reassemble again when the camp bell rang the call to worship and, hopefully, to salvation. Over the next two centuries, attendance at Camp Meetings and revivals would ebb, flow, and evolve, depending upon economics, social conditions, and leadership.

The end of the Civil War in 1865 brought rapid social change, due in part to new technologies that had provided more efficient methods to produce war materials. Farmers left the farms and rural churches to move to the cities, where work and better wages offered new opportunities. Railroads and steamship lines provided fast and easy transport for middle-class families eager to escape the crowded cities for a summer vacation at the fashionable watering resorts such as Saratoga and Coney Island in New York and Long Branch and Atlantic City in New Jersey. This new mobility coincided with a new era of religious awakening and the emergence of revivals within various Protestant denominations.

In 1867, Reverend William B. Osborn, a Methodist preacher, attended a week-long outdoor Holiness Camp Meeting at Vineland, New Jersey. Osborn's enthusiasm was boundless, and he eventually found an ideal Camp Meeting site: a secluded community on the northern New Jersey coast, where spiritual and physical health could be renewed. Thus, on July 31, 1869, a group of ministers and friends camped at what is now called Founders Park. After a candlelight prayer service, they dedicated themselves to establishing a permanent Christian Camp Meeting community called Ocean Grove. From this simple beginning there would emerge a permanent town by the sea with police and fire departments, postal and telegraph offices, and other public services that would meet the needs of a growing Christian resort.

A petition was presented to the New Jersey legislature for incorporation of the Ocean Grove Camp Meeting Association. On March 3, 1870, a state charter was issued to the newly formed association. This charter granted the 26 trustees (13 ministers and 13 lay people) "the

authority to purchase and hold real and personal estate, to construct and provide all necessary works to supply said premises with water and artificial light and other improvements deemed necessary or desirable." The charter also gave the trustees the power to appoint peace officers as deemed necessary for the purpose of keeping order on the camp grounds and premises of the corporation.

Streets and eventually 1,971 lots were laid out. The first lot was purchased by James A. Bradley for $86. Another 372 lots, 30 by 60 feet in size, were quickly sold by the end of 1870. (Bradley, a New York businessman, would later purchase and develop the land to the north as the city of Asbury Park.) A new planning design was the "setback" concept. Beginning two blocks from the ocean, each structure approaching the beach was successively set back from its adjoining neighbor, thus assuring a view of the ocean from each home.

The growth of this unique 19th-century religious community was remarkable considering that the New York and Long Branch Railroad did not extend rail service from Long Branch to Ocean Grove until August 1875. By 1877, about 710,000 railroad tickets were sold for the Ocean Grove and Asbury Park railroad depot.

Ocean Grove established various rules and regulations, including perhaps the most famous: the banning of all carriages and automobiles on the streets on Sunday. Others included restrictions on beach bathing on Sundays and the prohibition of the sale of liquors within a one-mile radius of Ocean Grove. On one Sunday in 1875, Pres. Ulysses S. Grant arrived by carriage to Ocean Grove. When he encountered a set of chained gates barring his entrance, he simply tethered his horses there and walked the remaining half-mile to his sister's house on Wesley Lake. From there, he continued to the open-air auditorium where 5,000 children, adults, and Civil War veterans welcomed him in voices of praise.

In 1975, Ocean Grove received the designation of a State and National Historic District as an example of a 19th-century planned urban community. The district contains the largest aggregate of Victorian and early-20th-century structures in America. The Board of Architectural Review was established in 1976 to create exterior design standards, ensuring that the district would maintain its existing architectural heritage of Victorian seaside cottages.

At one time, 660 tents were leased or owned on individual lots throughout Ocean Grove. Today, only 114 tents remain, standing in a semi-circle around the Great Auditorium. Each spring, by May 15, the canvas tents are brought from their backroom shed to be erected over the front wooden platform transforming it into a living room, to be furnished with couches, chairs, rugs, lamps, and pictures. Meanwhile, outside along the walks, flowers are planted by the tenters, many of whom are proud to be third- and fourth-generation summer Ocean Grovers. Similarly, throughout the historic district, pre-season events begin in the Victorian seaside cottages as hotel owners rush to complete that last-minute paint touchup on porches or rockers, in preparation for the onslaught of visitors, friends, and grandchildren. The summer Camp Meeting then continues as it has for over 130 years until the fall, when the tent canvases are taken down and stored until the next season.

This is Ocean Grove, now a year-round community where neighbors help and care about each other, a place where one can find rest, recreation, religious riches, and personal renewal. Ocean Grove, created in the 19th century, is truly a model for the 21st century.

One

BEGINNINGS

Rev. William B. Osborn attended a Camp Meeting in Vineland, New Jersey, from July 17 through July 26, 1867. From this simple religious experience, there would emerge the National Camp Meeting Association for the Promotion of Holiness. This association would travel far and wide, holding Holiness Camp Meetings throughout the United States, many of which are still active today. It was Osborn's spiritual mission to find a Camp Meeting ground in New Jersey by the seaside; this setting would allow desired rest and great salvation to be secured at the same time. Osborn is the founder of Ocean Grove.

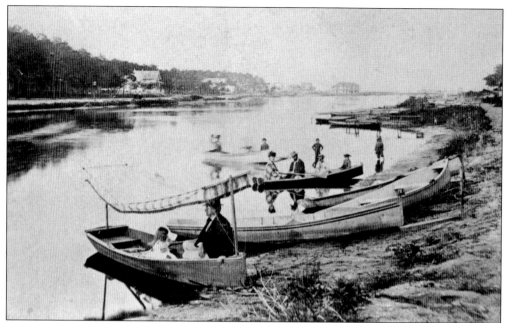
The early development of Ocean Grove occurred between Lake Avenue and Main Avenue. Osborn had a good sense of practicality. Wesley Lake was a great recreation area for boating. Reports mention that at one time there were over 600 boats on the lake. (Historical Society of Ocean Grove.)

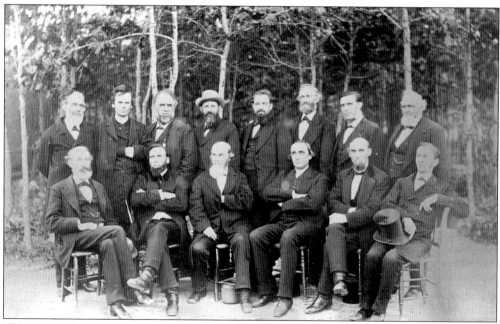
This is an early picture of the trustees. Included in the photograph are Alfred Cookman (back row, second from the left) and Elwood H. Stokes (front row, fourth from the left.) Each trustee was asked to donate $25 for the initial work of the Ocean Grove Camp Meeting Association. They were allotted two lots each at the starting price of $50. Thereafter, premiums were charged. All of the trustees served without pay. (Historical Society of Ocean Grove.)

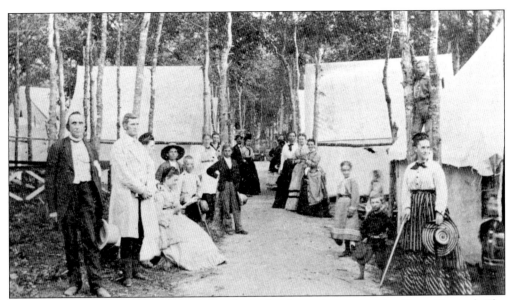

Simple walled tents were the order of residence for the early years at the Camp Ground. The entire area between Long Pond and Goose Pond was described as a place of briars, tangles of underbrush, thick holly, oak and maple trees, and the occasional small clearing. Lake names were changed to reflect Methodist Church history: Long Pond to the north became Wesley Lake, and Goose Pond to the south became Fletcher Lake. This 1870 photograph by Pach shows the primitive nature of the grounds along Lake Pathway. Dr. Stokes, wearing black, and Rev. Cookman, in the white coat, stand in the left foreground. (Historical Society of Ocean Grove.)

Tent living was very simple, with common cooking, eating, and washing areas. The grounds were swept clean of pine needles and oak leaves either by a broom or by the ladies' hoop skirts dragging on the ground. Here, one gentleman holds a croquet mallet, a common game at the seashore. A kerosene lantern hangs on the center tree. (Historical Society of Ocean Grove.)

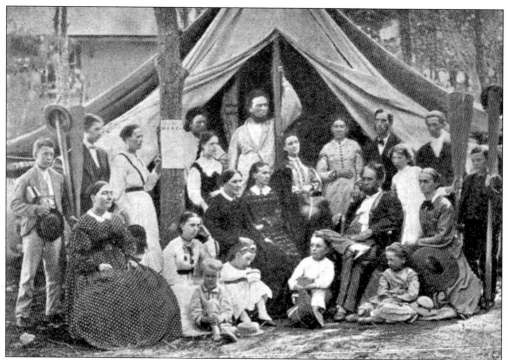

This is a typical 1870 family group portrait in front of a tent. The girl and the boys on the far sides are anxiously awaiting the photographer's nod so that they can go rowing on Wesley Lake. (Historical Society of Ocean Grove.)

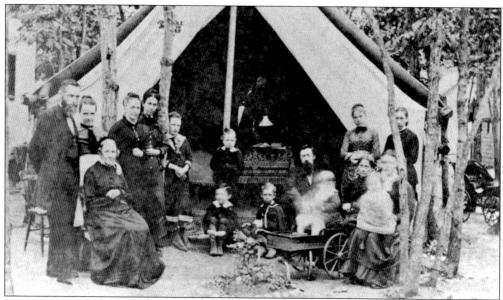

This photograph shows John L. Rile's tent, with Caroline Rile seated to the left. The wooden wagon is of typical 1870s vintage. Clamshells neatly encircle a small flower garden. The separate canvas over the tent, termed a "fly," is used to protect the main tent from the harmful effects of the sun and rain. It also allows for cooler temperatures in the tent. (Historical Society of Ocean Grove.)

OCEAN GROVE

TENT CIRCULAR

For 1883

TENT RENTS– with Floor and Fly included.

SIZE.			Per Week for Four Weeks.	Per Week for Additional Time.	
Wall Tent		9x9 feet.	$2 50	$2 00	After September 1st.,
"	"	9x12 "	3 00	2 50	SPECIAL RATES.
"	"	12x14 "	3 50	3 00	
"	"	14x14 "	4 00	3 50	Choice Locations
"	"	14x16 "	4 50	4 00	
"	"	14x19 "	5 00	4 50	50 cts. to $1. per week
"	"	14x21 "	5 50	5 00	Extra.

A number of New Cottage Tents, at Special Rates.

FURNITURE FOR TENTS, is Rented at the Following Rates.

ARTICLES.	For 2 Weeks.	For Longer Time.	
Bedsteads	$1 50	$2 00	
Double Cot	1 00	1 25	**Portable Kitchens.**
Single Cot	75	1 00	
Double Mattress	2 00	2 50	
¾ "	1 50	1 75	7x8 ft. 8x10 ft.
Single "	1 00	1 25	
Pillows, per pair	25	30	
Bolsters	25	30	$7.00 $10.00
Table, (without leaves)	75	1 00	
Wash Stand	50	75	
Chairs, each	25	35	
Rocking Chairs	Special.		

No furniture rented for less than 2 weeks, except by Special Agreement, and at Special Rates.

PRIVATE TENTS.

Persons owning their Tents, can be furnished with Posts, Poles and Floor, and have them put up at reasonable cost, on the best locations we have to offer.

Payments required in advance. Bills payable at the office of the Association.

Tenants are not allowed to sub-let to others.

Charges will be made from the time tents are ordered to be ready, whether occupied or not.

In ordering tents state the size desired, the date to take possession, and the length of time to be occupied.

Send full name and Post Office address. FROM STRANGERS, REFERENCES WILL BE REQUIRED.

By order,

GEO. W. EVANS, Sec'y.

Everything in the way of home furnishings was available from the Ocean Grove Camp Meeting Association. This made it easy for families who could only be in Ocean Grove for a month and not for the entire season. (Historical Society of Ocean Grove.)

One-room cottages were gradually added to the rear of the tents to serve as a second room and kitchen. Today, all the cottages contain a complete kitchen, a hot water heater, a toilet, and a shower. (Courtesy Judy Ryerson.)

In the winter, all of the summer furniture is stored in the cottage with just the tent platform left out in the open. By tradition, the closest tents around the Auditorium are called "the front circle." (Courtesy Judy Ryerson.)

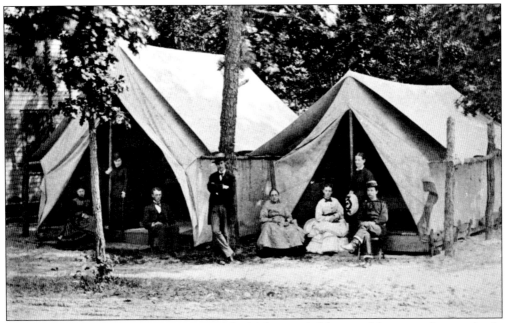

A smaller tent, like this one measuring 12 by 14 feet, probably rented for a month, completely furnished, to four people at a price of $39. Group portraits usually have a grim-looking grandmother in a black dress sitting on a chair. (Historical Society of Ocean Grove.)

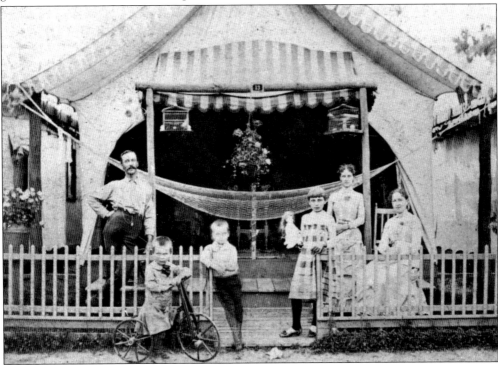

Tents were very much a way of life in the 1880s and 1890s. The birds in the two cages were also on a summer vacation. Today, many of the remaining 114 tents encircling the Great Auditorium house third- and fourth-generation families. (Historical Society of Ocean Grove.)

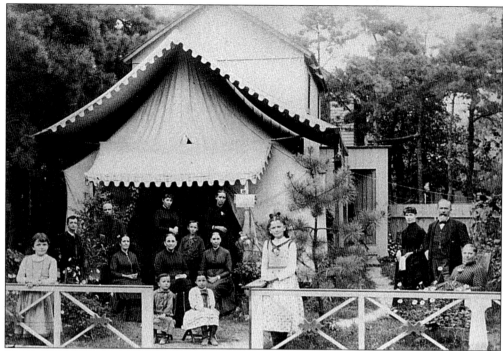

The Steinmetz family portrait, taken at 85 Embury Avenue, shows three generations. The tent in the front is attached to the house in the rear. (Historical Society of Ocean Grove.)

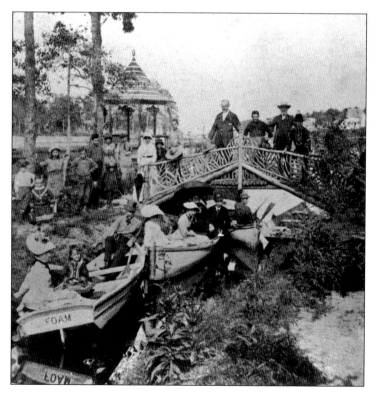

Boating was a pleasure enjoyed by many on Wesley Lake. One could row up to the lake's western end and picnic on a small island called Fairy Island. A gazebo in the rear of Rev. G. Hughes's cottage on Central and SeaView Avenues was moved to the island, and a bridge was constructed in 1875. (Historical Society of Ocean Grove.)

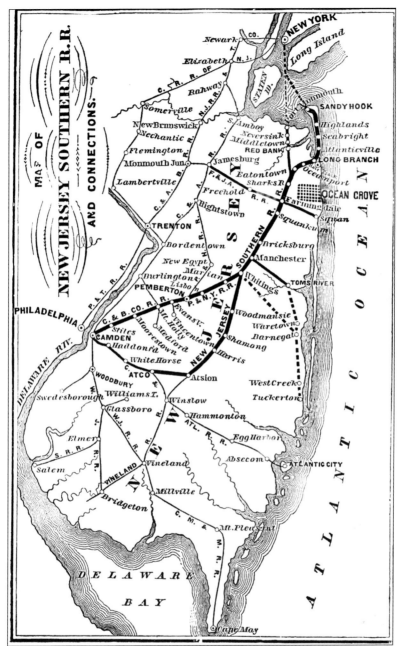

The journey to Ocean Grove was long and hard. From New York City and Brooklyn, one could travel by boat across lower New York Bay to dock either at Sandy Hook or Port Monmouth, then travel by rail to Long Branch. From Philadelphia, one could travel by rail to Monmouth Junction, Jamesburg, Farmingdale, and Squan Village. From there, after a bumpy wagon ride of six or seven miles, one would finally arrive at the gates of Ocean Grove. In 1874, about 40,000 people visited the grounds during the season. It was not until August 28, 1875, that the New Jersey Southern Railroad extended its tracks from Long Branch to Ocean Grove. By 1877, it was estimated that 300,000 people had come to Ocean Grove with no less than 50,000 pieces of baggage and express packages. (Historical Society of Ocean Grove.)

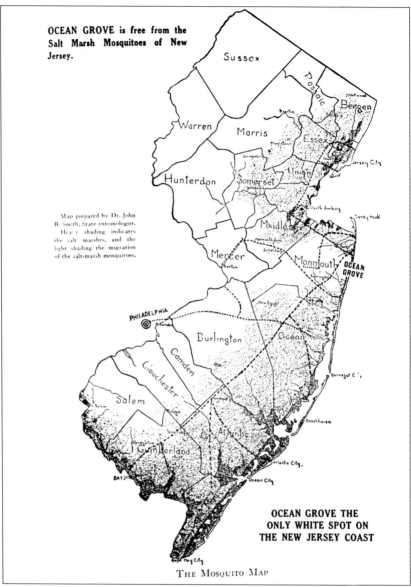

The Mosquito Map

Elwood H. Stokes, D.D., LL.D., (1815–1897), was president of the Ocean Grove Camp Meeting Association from 1869 to 1897. President Stokes was very sensitive to health and sanitation issues. Even the mere rumor of a contagious disease (such as typhoid) could have easily caused the economic collapse of the Camp Meeting. The sanitary officer and physicians who were members of the Ocean Grove Board of Health enforced strict controls on garbage disposal, cesspools, and the cleaning of privy vaults with disinfectant. Early annual reports of the Ocean Grove Camp Meeting Association provided a list with the ages of individuals who died while at the Camp Meeting grounds. In 1880, there were 15 deaths reported—half of them less than one year old. According to the annual report, "they had been brought to Ocean Grove in the hopes that the sea air might save them." Ocean Grove's healthy environment, free from salt marsh mosquitoes, is shown above in a map prepared by Dr. John B. Smith, the state entomologist in New Jersey. The absence of mosquitoes figured prominently in Ocean Grove advertisements. (Historical Society of Ocean Grove.)

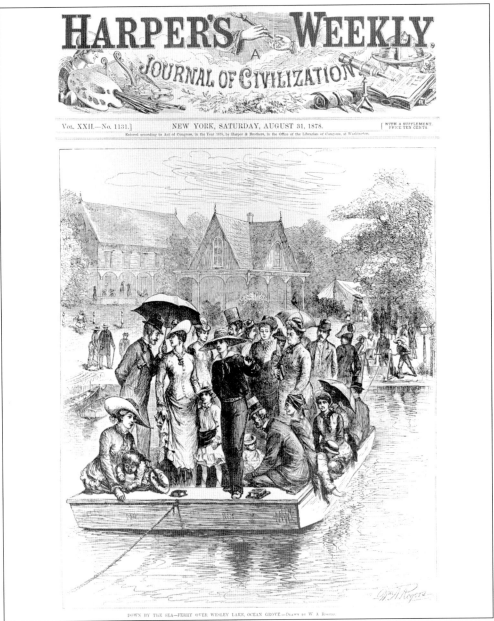

On August 31, 1878, *Harper's Weekly* featured this engraving of Ocean Grove on the front page. Two ferryboats, one at Pilgrim Pathway and the other at New Jersey Avenue, were in constant use on Wesley Lake to accommodate the ever-increasing number of visitors. Licenses were also issued to 83 boat owners to transport visitors in their boats. The summer population had increased to over 18,000 people, and Ocean Grove now boasted 721 substantial residences and 506 tents. At this time, Ocean Grove had a strong reputation for excluding everything suggestive of vice or dissipation. Along with its neighbor of Asbury Park, Ocean Grove tried to enforce total abstinence from spirituous liquors. (Historical Society of Ocean Grove.)

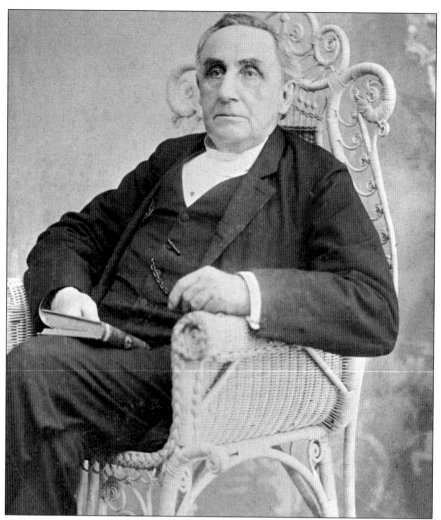

Born of Quaker parents in Medford, New Jersey, Ocean Grove Camp Meeting Association president Elwood H. Stokes was the youngest of seven children. His initial education consisted of a few months each year until, at age 13, he was apprenticed to the bookbinder trade in Philadelphia. He rose to the position of foreman at James Crissy Publishers, where he credited his employer with providing him a background in the reading of the classics. At age 25, he entered the New Jersey Annual Conference of the Methodist Episcopal Church. He was given active ministerial appointments to churches both in the northern and southern church districts of New Jersey. Stokes was a sound choice to be the president of the association. His quiet leadership was the driving force in setting the standards that emerged as Ocean Grove. He was the corresponding editor of the *Ocean Grove Record* for 26 years. The annual reports of the association from 1870 to 1896 were authored by Stokes. His poetic temperament produced two poetry books: *Blossoms* and *Starlets by the Sea*. A third book, *What I Saw in Europe*, details in prose his trip abroad. Another accomplishment was the construction of the Great Auditorium in 1894. He died of atheroma at his home on the corner of Pitman and Beach Avenues on July 17, 1897. His body lay in state at the Great Auditorium until Tuesday morning, July 20, when mourners filled the auditorium for a memorial service. After the service, a special train conveyed the funeral cortege to Haddonfield, where he was interred at the family burial ground. His greatest achievement was Ocean Grove. (Historical Society of Ocean Grove.)

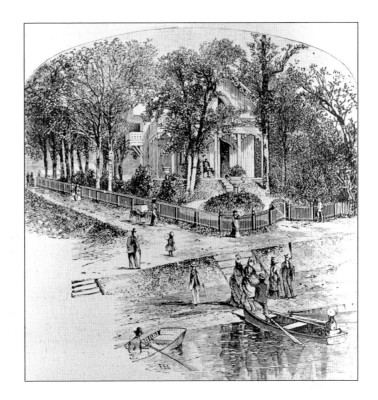

Sylvandale Cottage, standing at the corner of Lake Avenue and Wesley Place, was the first residence of Rev. E.H. Stokes, the president of the Ocean Grove Camp Meeting Association. This 1874 engraving by E.F. Williams identifies the name of the first boat on Wesley Lake as *Sylvandale*. (Historical Society of Ocean Grove.)

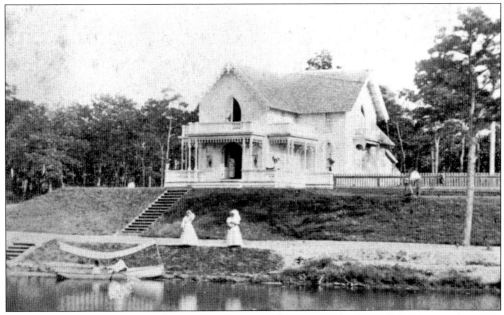

The residence of J.K. Haywood, Esq., was located at the corner of Lake and New Jersey Avenues. The lot has since been cleared, and steps lead down to the walk along Wesley Lake. New Jersey Avenue was the location of one of the two toll ferryboat crossings on the lake. This impressive cottage, owned by a lawyer, projected an unspoken belief and value in Ocean Grove. (Historical Society of Ocean Grove.)

Children enjoyed wading in Wesley Lake when the water level was below their rolled up pants. The depth of the lake varied, depending on the dam at the eastern end and on the number of summer rainstorms.

The charm of the walk around Wesley Lake is illustrated by the ladies and their open parasols. Strolling was an encouraged activity with an established etiquette. It was an excellent opportunity for young ladies to observe young men. Formal calling at home or in the tent would follow.

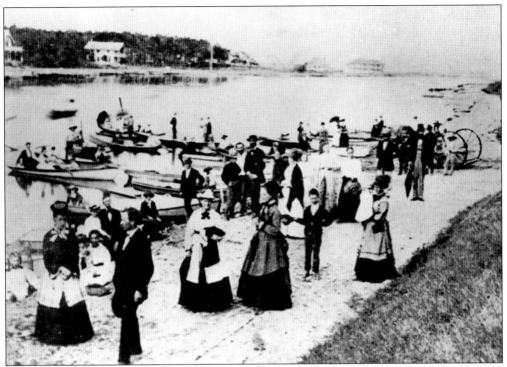

Large numbers of pleasure boats crowded the New Jersey Avenue ferry dock. The wheeled object on the far right was used on the boat ramp to launch and haul the vessels. (Historical Society of Ocean Grove.)

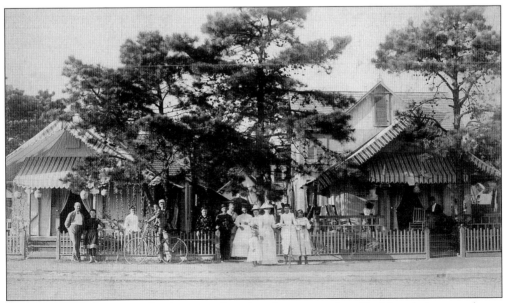

Japanese lanterns were popular decorative hangings for tent awnings. Rocking chairs were also an essential front porch item. Bicycles were the simplest and easiest forms of transportation in Ocean Grove when you needed something from the stores. (Historical Society of Ocean Grove.)

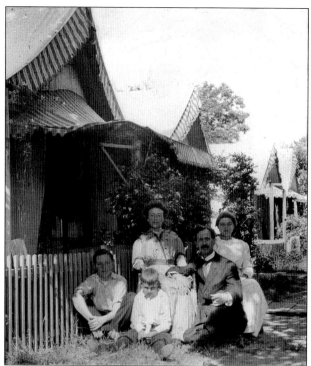

In this family portrait, the mother in the rocking chair smiles approvingly at her husband and three children. It is probably Sunday, since her husband is dressed in a fine suit, starched collar, and cufflinks. The vines on the post appear to be Japanese honeysuckle with its fragrant flowers. (Historical Society of Ocean Grove.)

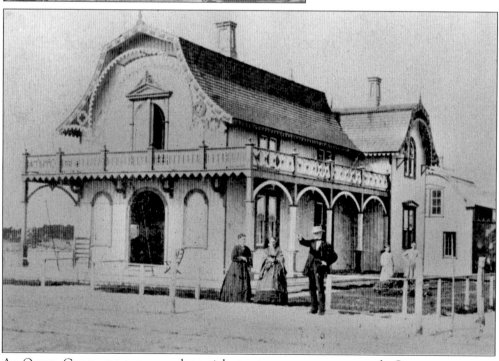

As Ocean Grove grew, more substantial structures were constructed. One- or two-room dwellings were quickly improved to four- to eight-room seaside cottages with two stories. Dr. Ward's cottage on Ocean Avenue, with its dual pitched concave roof and decorative bargeboards, is typical of the mid-1870s. (Historical Society of Ocean Grove.)

Two
FROM TENTS TO COTTAGES

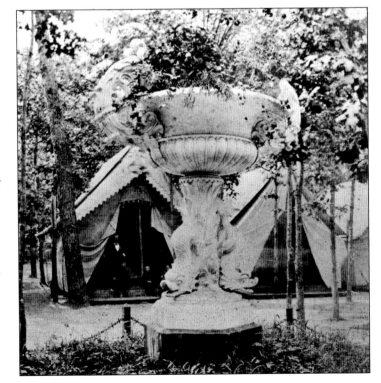

Pioneer Vase, a cast iron Fisk Foundry urn, was erected in honor of the women pioneers at Ocean Grove. The dolphins readily identify this vase from the two others of similar size in Ocean Grove. The urn has been moved three times. It was shipped to Birmingham, Alabama, in 1971 for major restoration. It is currently on the corner of Broadway and Central Avenue. (Historical Society of Ocean Grove.)

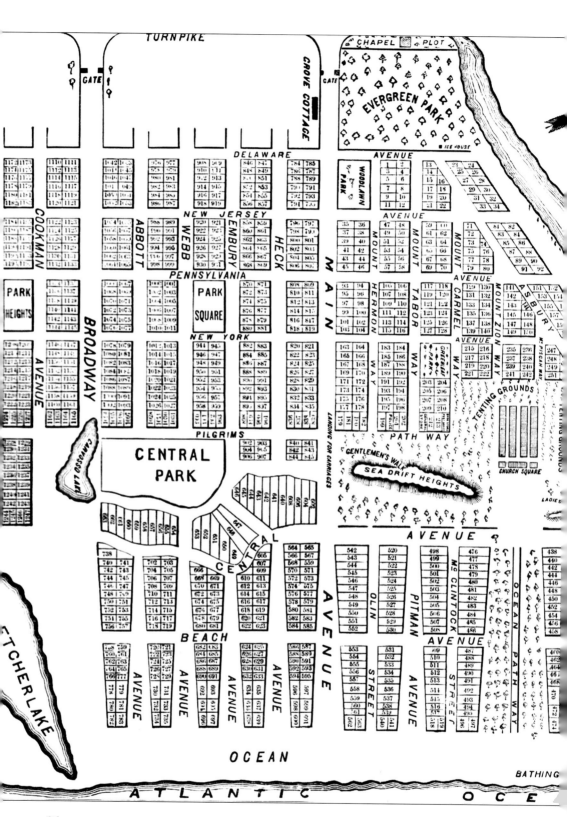

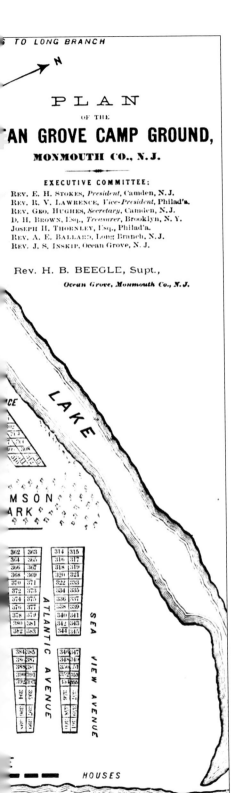

The earliest map of Ocean Grove (1871) shows the innovative setback concept for the first two blocks from the ocean. The funnel design enhances the sea and land breezes, providing a welcome cooling effect for summer vacationers sitting on their porch rockers. Gentlemen's Walk and Ladies Walk are old coastal dunes where comfort stations were located. Carvosso Lake was filled with material from Sea Drift Heights. (Historical Society of Ocean Grove.)

What makes Ocean Grove unique is that once the Ocean Grove Camp Meeting Association acquired the land, it was never again sold. Instead, the Camp Meeting grounds were divided into small lots averaging 30 by 60 feet. The lots were leased at $10.50 per year for 99 years, subject to the approval of the association. The lot size tended to restrict the design of the house even if two lots were leased. This is a typical two-story Victorian seaside cottage with side bay windows on a leased 30- by 60-foot lot. The porch overhang above the two ladies is called a "pent" or an "eyebrow" and is common in Ocean Grove. The pent provides shade to the porch, as well as a means to channel rainwater from the second floor porch directly to the ground. Removal of the pent has forced many a homeowner to replace the front porch much sooner than normal by exposing three feet of the lower porch to the weather.

With its L-shaped ground- and second-floor porches, this cottage is typical of 1880 construction. Vines were a favorite plant to block the summer sun. The shutters were also effective. Common fences included the 18-inch-high fence of 1.5-inch iron pipe, shown in the foreground, as well as the wire fence covered with vines to the right. While there were no mosquitoes in Ocean Grove (according to the New Jersey state entomologist), the high birdhouse structure (right background) housed purple martins, birds always eager to catch any flying insects. (Courtesy William Kresge.)

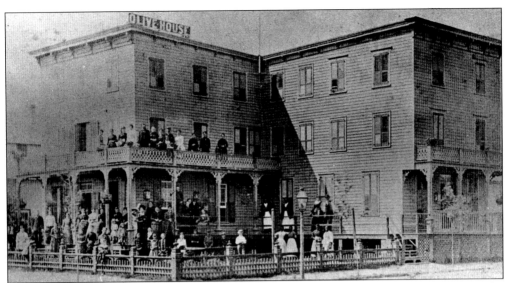

The Olive House at the northwest corner of Heck and Beach Avenues was built in 1876 by John Green of Philadelphia. This early picture by Pach shows the hotel staff to the right and the guests, standing to the left on entrance floor and the first sleeping floor. Kerosene and gas streetlights were a prominent early feature in Ocean Grove. The planting of trees along the street was always encouraged by Stokes. (Courtesy Mary Jane Schwartz.)

By the turn of the century, the Olive House's open side-porch (right) had been turned into an enclosed glass sunroom. Striped awnings were added to the south Heck Avenue porch. Things that were not changed were the wooden rocking chairs and their comfortable, soothing motion. Early trees in the first two blocks did not fare well in the salty sea breezes. In addition, trees planted in the setback of the first two blocks would obscure the ocean view of one's western neighbor. (Courtesy Mary Jane Schwartz.)

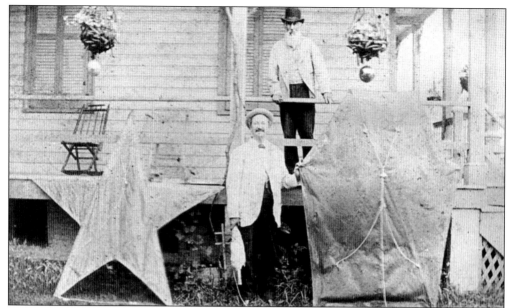

Recreation included bicycling to Shark River, walking to Sunset Lake in Asbury Park, playing croquet on the lawns, swimming at the beach, boating, fishing, and kite-flying. The size of these two homemade kites indicates strong winds at the beachfront. The silver balls under the hanging plants are a Victorian decoration. John Green, the builder, is holding the kite. John Montgomery, the carpenter, is standing on the porch. (Courtesy Mary Jane Schwartz.)

The Jackson House—seen here in a typical group portrait with picket fence and vines—was located at the southwest corner of Heck Avenue and Pilgrim Pathway. The woman in dark glasses, third from the tree, is Fanny Crosby (Frances Jane Crosby Van Alstyne, 1820–1915). Crosby was the blind poetess whose hymns were sung at many Holiness Camp Meetings throughout the world. Her words were set to music by some of the leading composers of the time: William H. Doan, John R. Sweney, William J. Kirkpatrick, and Phoebe P. Knapp. Among the more than 8,000 hymns and poems that she wrote are *To God Be The Glory, Redeemed, Jesus is Calling, Blessed Assurance, Pass Me Not* and *Rescue the Perishing*. (Courtesy William Kresge.)

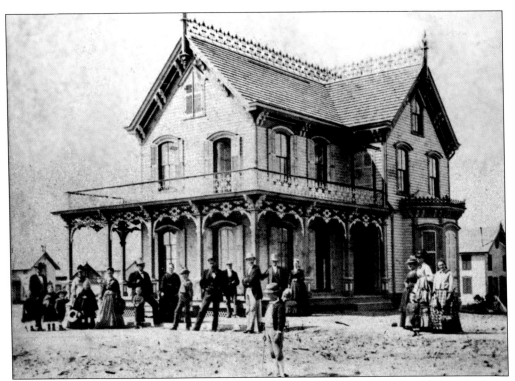

The residence of Mrs. E. Sheridan at the corner of Main and Ocean Avenues exhibits the fancy gingerbread decorations of the late 1870s. The brackets on the front porch appear to be made of solid wood with raised and painted decorations. The railing on the second floor and the roof cresting are cast iron. (Historical Society of Ocean Grove.)

Decorative rowboats with padded cloth seats were numerous on Wesley Lake. Young boys would charge 1¢ per crossing from either Asbury Park or Ocean Grove, the same toll charge of walking across one of the two Wesley Lake bridges. A carnival was held every summer on the lake, with each boat owner determined to outdecorate the others. One newspaper account described the evening of the boat carnival as "outshining even Venice." (Historical Society of Ocean Grove.)

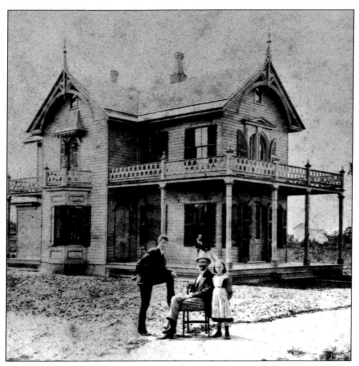

Shown is the residence of Rev. H.B. Beegle at the corner of Main and Delaware Avenues. Beegle was appointed superintendent of the Ocean Grove Camp Meeting Association after Osborn resigned in 1871. In the beginning, lots were only to be used or occupied as private residences from May 15 until October 30 each year. Special extension cases for general convenience were allowed only by the action of the association or executive committee. (Historical Society of Ocean Grove.)

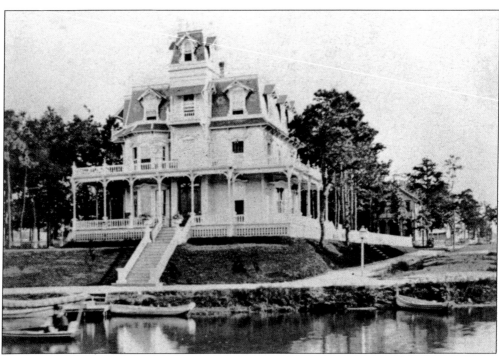

This second empire building with its mansard roof and cupola was the residence of Prof. E.R. Sanders. It stands on one of the odd, large lots near Lake and Whitefield Avenues. The projecting central pavilion, the two-story bay windows, the dormers, and cornices qualify it as what might be called an "Adams family" summer home. (Historical Society of Ocean Grove.)

Ocean Grove was not just for Methodists. Inside the Main Avenue gates stood the Charles Rogers house, or Grove Cottage, standing on one of the ten original tracts that were purchased to form Ocean Grove. The house was enlarged and, in 1876, renamed "Elim Cottage." In the Bible, "Elim" means "place of rest." Elim Cottage was free to ministers of all faiths who might visit Ocean Grove. The 1881 annual report lists 141 guests. Of these, 72 were Methodist, 24 Presbyterian, 10 Lutheran, 2 Reformed Catholic, 1 United Brethren, 7 Baptist, 5 Episcopalian, and 4 Reformed Episcopalian. They were from New York (51), New Jersey (34), Pennsylvania (32), Maryland (8), Connecticut (4), Dakota (4), Delaware (3), Ohio (2), New Hampshire (1), Texas (1), and England (1). In 1937, the cottage was removed, and the lots were sold. (Historical Society of Ocean Grove.)

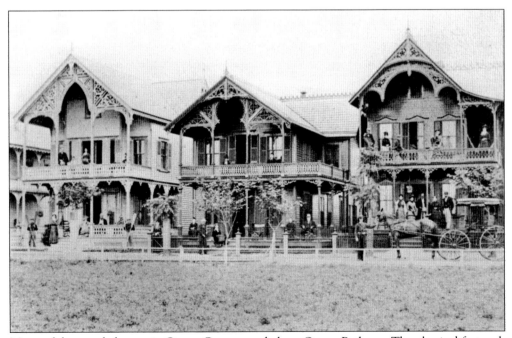

Many of the stately homes in Ocean Grove stand along Ocean Pathway. The classical fretwork and the Moorish arches exemplify the Victorian fascination with the jigsaw machine. (Historical Society of Ocean Grove.)

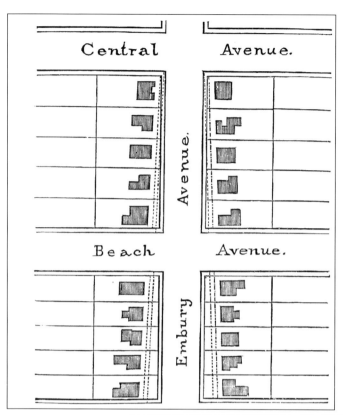

This sketch of Embury Avenue illustrates the widening of the setback on the lots as they approach the ocean. The setback at Central Avenue is two feet and increases to ten feet at Ocean Avenue. (Historical Society of Ocean Grove.)

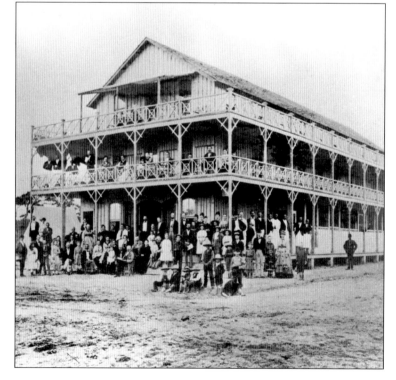

Pach, a local photographer, took many pictures of guests and staff at the hotels in Ocean Grove. The Osborn Hotel stands on two lots. The main entrance (center) leads to a parlor and a dining room. Sleeping rooms were provided with doorway curtains to allow for the movement of ocean breezes through the halls. (Courtesy George Moss.)

Families would also rent a group of tents. Once you have experienced tent life, it is very difficult to give it up, as many Ocean Grovers have discovered. If you are having breakfast and you ask your wife to pass the salt, you may hear someone from the next tent reminding you of your salt-reduced diet. (Historical Society of Ocean Grove.)

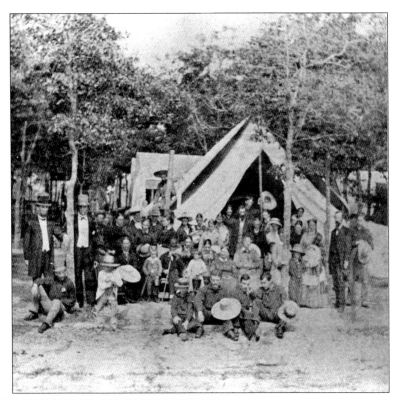

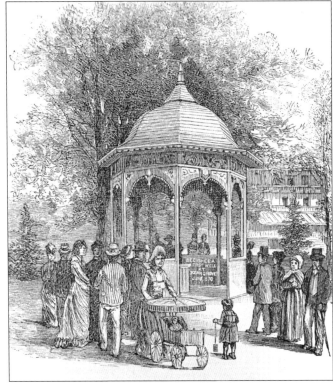

In June 1870, the first pump well was driven in Ocean Grove near the corner of Pilgrim Pathway and Mount Carmel Way. Its name, Beersheba, comes from a well in the Old Testament in Israel. The 1871 gazebo over the well has been adopted as the symbol of the Historical Society of Ocean Grove. A local contractor, John Case, maintains the structure as his donation to the historical society. (Historical Society of Ocean Grove.)

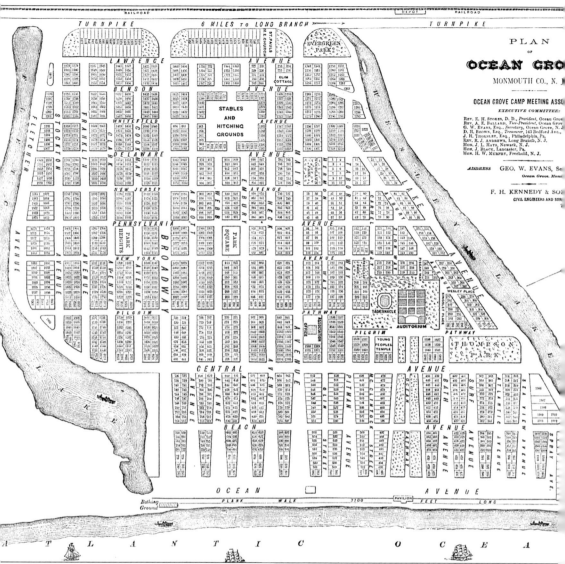

The 1878–1879 plan of Ocean Grove reflects the complete purchase of all the land between the two lakes. The Asbury Park–Ocean Grove railroad station is to the north. There was an icehouse on Fletcher Lake, but it was not practical due to warm winters. Ice would be purchased at White Haven in the Poconos, then shipped and stored in the icehouse for summer sale. Later, Fletcher Lake (from Pennsylvania Avenue west to the turnpike) would be filled in and its lots sold. The Fletcher Avenue name would be changed to Inskip Avenue in memory of John Inskip, a trustee of the Camp Meeting Association and one of the leaders of the Holiness Movement. Park Square would be given to St. Paul's Methodist Episcopal Church when the church relocated due to the construction of the new Neptune Township High School on Lawrence Avenue. (Historical Society of Ocean Grove.)

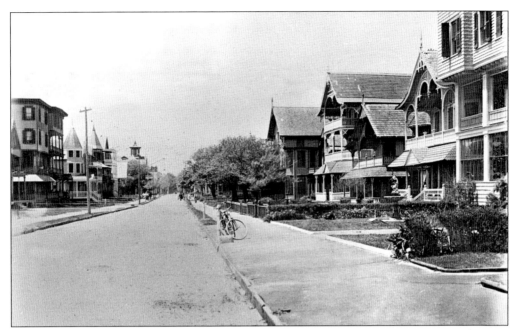

The setback and flaring avenue is obvious in this c. 1898 photograph of Pitman Avenue looking west. The street is of clay and sand. The curbing is three-inch-wide slate rather than the wooden hemlock boards that were first installed. The four single-family homes (right) each have a first floor pent, cedar shake roofs, pendants, and finials at the peaks of their roofs. Two of the houses have tile cresting along the roof ridge. On the right is a water fountain decorated with cast iron vines at the base and a kneeling child above the basin. On the left side of the street are two houses typical of the Queen Anne style, with towers and asymmetrical facades.

Early Camp Meetings were a time for socializing as well as for spiritual renewal. The tree-lined sand pathways, the coolness of the woods, and the ocean's wave action provided a welcome relief to the city dweller. (Historical Society of Ocean Grove.)

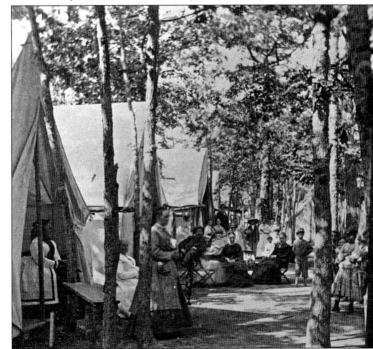

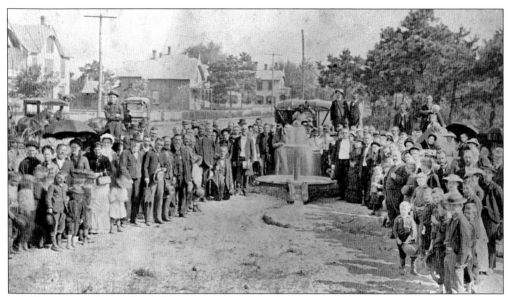

Health concerns were always foremost in the deliberations of the Ocean Grove Camp Meeting Association. In 1883, there were 800 home tube wells. Although four and one-half miles of common sewerage pipe had been installed, criticism of the association resulted in a concentrated effort to provide for a safe, reliable source of water. A four-inch diameter well was bored 420 feet into the ground near the head of Fletcher Lake. After six months, water was at last found in such abundance and pressure that it would rise in pipes 28 feet above the ground. The flow was measured at 43 gallons in two minutes, 35 seconds at 18 feet, nine inches above ground. Reverend Stokes is to the right of the fountain in black suit and white shirt. (Historical Society of Ocean Grove.)

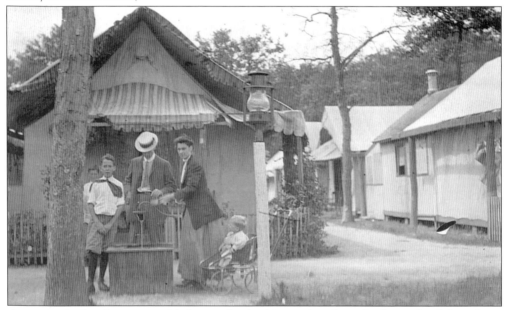

A community hand pump provided water for drinking and cooking for those who did not have pumps in their tents. A cup on a string was available at the well unless you brought your own. (Courtesy James Lindemuth.)

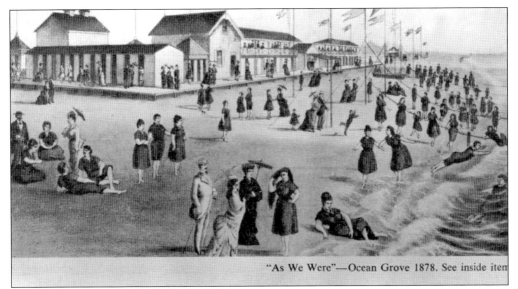

"As We Were"—Ocean Grove 1878. See inside item

The 1878 Wolman and Rose atlas featured this scene at Lillagore's Pavilion in Ocean Grove. (Historical Society of Ocean Grove.)

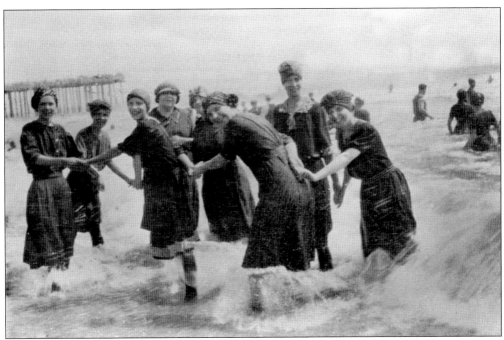

Ocean Grovers of the late 19th century had again discovered the joy of ocean bathing. It was encouraged in Ocean Grove, except on Sundays, when it was prohibited. In 1875, Rev. E.A. Ballard wrote, "The rush of the sporting waters, spattering, spluttering, frisking, running and ducking, enters every pore and washes away the humors which had before been driven from their ambush. . . . Sometimes a wise and revered head will be pushed down under waters by another head as wise and revered as itself. The laughter is 'catching,' and the veriest trifles excite fresh peals of merriment, chattering, pushing, scattering sand over each other, in the flush of full life." (Historical Society of Ocean Grove.)

SIGNIFICANCE OF THE NAMES OF THE STREETS OF OCEAN GROVE

Streets running north and south:

OCEAN AVENUE—Paralleling the ocean.
BEACH AVENUE—On the beach second from the ocean.
CENTRAL AVENUE—The main thoroughfare, north and south.
PILGRIM PATHWAY—Leading from both directions to the camp grounds.
WESLEY PLACE—A short street from Lake Avenue to the Auditorium; named for John Wesley.
NEW YORK AVENUE—For the State of New York.
PENNSYLVANIA AVENUE—For the State of Pennsylvania.
NEW JERSEY AVENUE—For the State of New Jersey.
DELAWARE AVENUE—For the State of Delaware.
WHITEFIELD AVENUE—For the noted preacher George Whitefield.
BENSON AVENUE—For the Rev. Joseph Benson, an eminent preacher of England.
LAWRENCE AVENUE—For Ruliff V. Lawrence, first vice-president of the Association.

Streets, east and west from the north, southward:

LAKE AVENUE—To the south of Wesley Lake from the turnpike (now Ocean Boulevard) to the ocean.

East of "Sea Drift Heights":

SPRAY AVENUE—One block in length ending at the ocean.
SEAVIEW AVENUE—Two blocks in length ending at the ocean.
ATLANTIC AVENUE—The Atlantic Ocean.
SURF AVENUE—The Surf.
BATH AVENUE—Terminating at the location of the bathing grounds.
OCEAN PATHWAY—Appropriately named, extending from the camp grounds and Auditorium to the ocean, exactly five hundred yards in length with beautiful parkways to the north and south. Two hundred feet wide at Auditorium and three hundred feet wide at the ocean.
McCLINTOCK STREET—The Rev. James McClintock.
PITMAN AVENUE—The Rev. Charles Pitman, D.D.
OLIN STREET—The Rev. Stephen Olin, D.D.

West of "Sea Drift Heights":

KINGSLEY PLACE—Bishop Calvin Kingsley.
MOUNT PISGAH WAY
MOUNT ZION WAY
MOUNT CARMEL WAY } Named for noted mountains of Scripture.
MOUNT TABOR WAY
MOUNT HERMON WAY

Extending from the Turnpike (now Ocean Boulevard) to the ocean:

MAIN AVENUE—For many years the main street of Ocean Grove.
HECK AVENUE—For Barbara Heck.
EMBURY AVENUE—For Philip Embury.
WEBB AVENUE—For Captain Thoms Webb.
ABBOTT AVENUE—For Benjamin Abbott.
BROADWAY—Named for its breadth.
COOKMAN AVENUE—For the Rev. Alfred Cookman, a charter member of the Association.
CLARK AVENUE—For the Rev. Adam Clark.
FRANKLIN AVENUE—For George Franklin, Esq., a charter member of the Association.
STOCKTON AVENUE—For the Rev. J. H. Stockton, a charter member of the Association.
INSKIP AVENUE—For the Rev. John S. Inskip, a charter member of the Association.

The names of the streets and avenues in Ocean Grove reflect scripture, Methodist history, descriptive seashore terms, and nearby states. A catch question in Ocean Grove is, "How many streets are there in Ocean Grove?" (Answer: two.)

Three
AUDITORIUM SQUARE

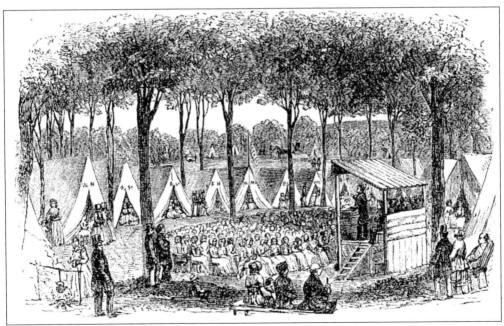

Most Camp Meetings were held in rural areas for a seven to ten day period. A farmer's field or a forested glen with a good source of water were critical to the success of the revival. This 1854 engraving details the speaker preaching from a simple raised, covered platform to a seated crowd of about 300 worshipers. (Historical Society of Ocean Grove.)

The Church Square is the center of religious activities at a Camp Meeting. In Ocean Grove, it was not until 1876–1878 that the term "Auditorium" was used and accepted. Before that time, the first structure was called a preacher's stand. The stand was described as an octagon form capable of seating 75 or more ministers. The stand was surmounted by a cupola with a small sweet-toned bell. The stand is visible in the center of the grove of trees. (Historical Society of Ocean Grove.)

In 1875, a more substantial frame (75 by 100 feet with 16-foot-high posts) was erected. This was covered with tent flies and pine boughs, which would provide shelter from the sun but not the rain. One hundred fifty park settees were purchased from the Pitman Grove Camp Meeting Association in Gloucester County, New Jersey, to accommodate the crowds. (Historical Society of Ocean Grove.)

In 1877, the size of the Auditorium was again increased to a seating capacity of 3,000 people. Nighttime lighting was provided by a small gas-making plant and kerosene lamps. A permanent roof was installed, but it was necessary to conduct a vote of the worshipers in regard to the roof improvement. (Historical Society of Ocean Grove.)

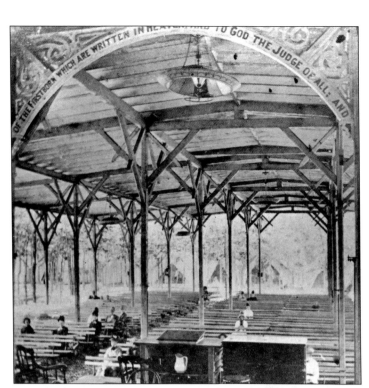

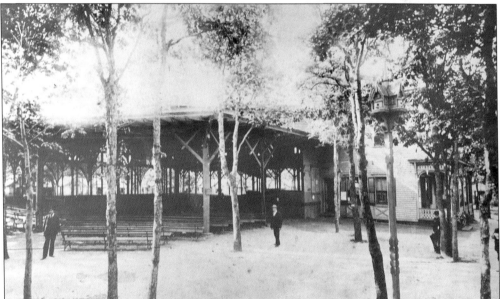

Reverend Stokes can be seen walking around the outside of the third Auditorium in the center of this photograph. The house to the right was for reception and to house the speakers at the services. Sleeping quarters were on the second floor, and a full cellar provided ample room for a gas generator that illuminated the Auditorium. In 1888, the Auditorium was lighted with electric lamps. The house was moved across the street to the Mount Carmel Way and Pilgrim Pathway. It now functions as the Methodist Bookstore. The small birdhouse is an example of natural insect control. (Historical Society of Ocean Grove.)

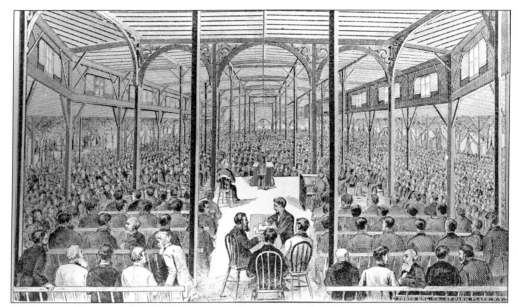

In the annual report of 1889, Stokes strongly recommended that a new and better-constructed Auditorium, with improved acoustics, was necessary to accommodate the ever-increasing number of worshipers. Immediately, unsolicited funds were given to the Ocean Grove Camp Meeting Association as a show of support for the new Auditorium. In 1890, Stokes reported on one lady who walked up to him and presented him with $100 in gold as a donation. The average wage at the time for a clerk in a clothing store was between $1 and $3 per week. (Historical Society of Ocean Grove.)

On Sunday, August 13, 1893, a large rally was held at the old Auditorium. The "New Auditorium Day" rally was chaired by James A. Bradley, Dr. Hanlon, C.H. Yatman, and President Stokes, all of whom gave addresses for this endeavor. At the end of the day, $41,500 was contributed or pledged. A second rally was held on Dedication Sunday, August 12, 1894, where $35,000 was raised. Blackboards were used at the rally to chart the pledges. It was a statement of belief that when, and if, additional funds were necessary, they would be forthcoming from the faithful. (Historical Society of Ocean Grove.)

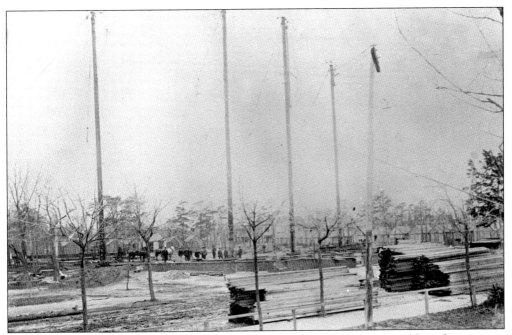

The construction of the new Auditorium began with the razing of the old Auditorium on October 16, 1893. The salvageable beams and posts were used to enhance and add to the Lillagore Pavilion at Fletcher Lake. Ginpoles (masts) were placed in position to hoist the iron trusses. (Historical Society of Ocean Grove and Ginger Hoffmeier.)

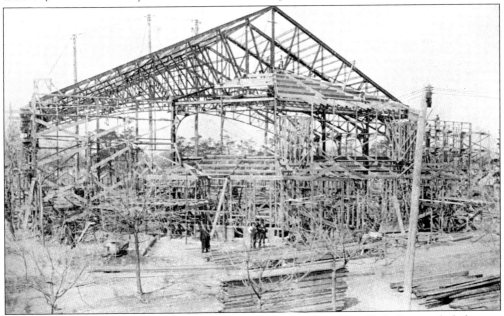

The design of the building by Fred T. Camp, an architect from New York City, included seven main trusses, with 161-foot spans, 21 feet apart. There are also 18 angle trusses. The first steel truss was lifted into position on Tuesday, March 6, 1894, with the rest of the ironwork completed by March 18. The dimensions of the building were 225 by 161 feet for a total of 36,225 square feet. (Historical Society of Ocean Grove.)

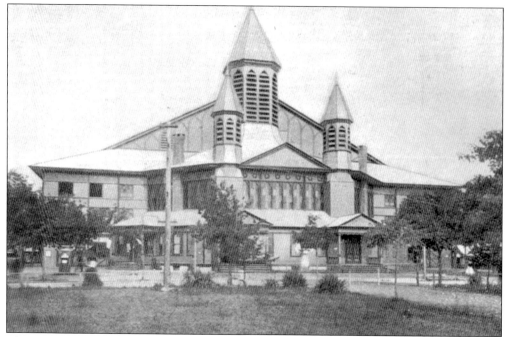

The Great Auditorium was completed in 92 working days. It was stipulated with the contractors that no work was to be done on the Sabbath and no profane or other unbecoming language was to be used on the grounds. Stokes reported that "in but a single instance in the very beginning of the work, and that, but momentarily, was the regulation violated." (Historical Society of Ocean Grove.)

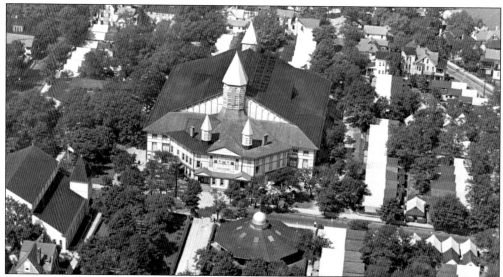

Statistics of the Auditorium include the following: the total number of doors and windows is 262, of which only 232 can be opened or closed; the roof of corrugated galvanized iron is 40,300 square feet; the height of the main tower up to the finial is 119 feet, with a 12-foot finial bringing the total height to 131 feet; the diameter of main tower is 18 feet; the height of front bell towers is 62 feet with finials of 8 feet, totaling 70 feet; and the diameter of the bell tower is 8 feet. (Historical Society of Ocean Grove.)

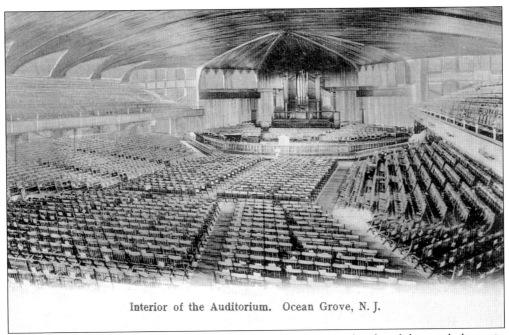

Interior of the Auditorium. Ocean Grove, N. J.

The entire ceiling is wainscot southern hard pine. The greatest height of the parabolic main ceiling from the floor is 55 feet. The height above the pine ceiling to the peak of the roof is 29 feet. The altar rail in front of the speaker's platform is 114 feet with a 6-foot space between rail and platform. (Historical Society of Ocean Grove.)

The first pipe organ was donated in 1895 by the Washington Square Methodist Episcopal Church in New York City. The expense of taking down, transporting, fitting up, including changes, and repairing the organ amounted to $1,300. An appeal from the platform resulted in a generous response that covered the entire cost. (Historical Society of Ocean Grove.)

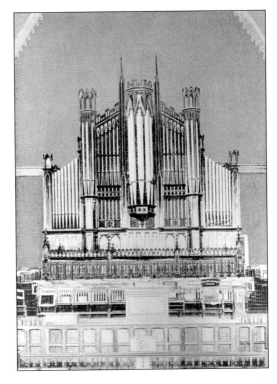

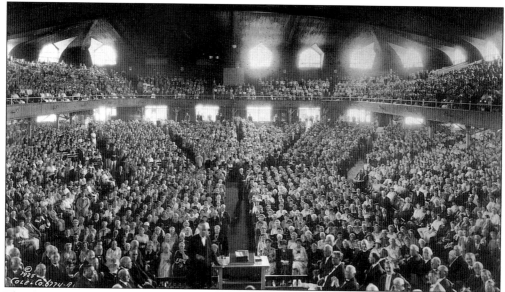

The 5,245 folding chairs from the Andrews Demarest Seating Company on the lower floor are all occupied for this c. 1925 interior photograph. The upper gallery area could accommodate about 4,000 people on benches, and the platform could accommodate 355. The total seating capacity was 9,600 people. Each occupant had a full view of the speaker. (Historical Society of Ocean Grove.)

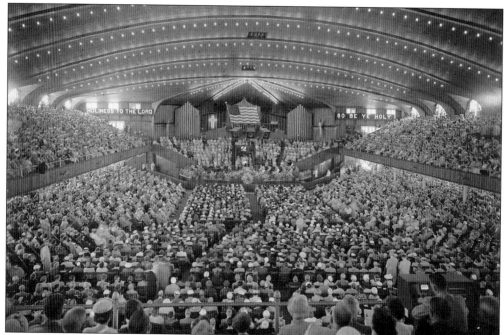

The building is lighted with 1,146 incandescent lamps (with a total candle power of 16,304). It was wired so that the number of lamps could be increased to 1,300 if needed. The lights are suspended from iron trusses in great arcs across the ceiling. The two lighted signs read "Holiness to the Lord" and "So be Ye Holy," stating the principles of the Holiness Movement in the Methodist Church of the late 19th century. (Historical Society of Ocean Grove.)

The ushers stand in the aisles to begin collecting the offering. The American flag (center) is comprised of a series of small lights that, when turned on, present the illusion of a flag waving in the breeze. The flag is always lighted on Memorial Day, Independence Day, and Labor Day, and whenever the "Star Spangled Banner" is sung. (Courtesy William Kresge.)

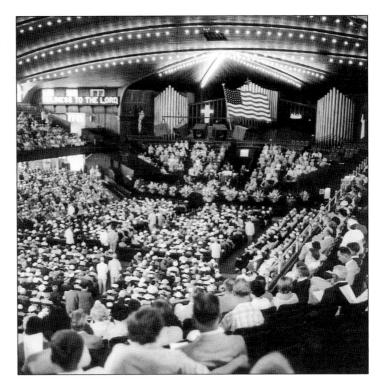

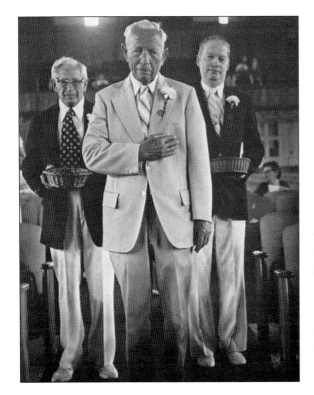

August Stoll, head usher for 35 years, gives the signal that begins the Ushers' March. The Auditorium organist, Clarence Kohlmann, composed the "Ushers' March," which is coordinated to the movements of the ushers as they precisely march to the altar rail with collection baskets. Shown are, from left to right, John Gerner, Augie Stoll, and Harvey Downing. (Courtesy Marilyn Pfaltz.)

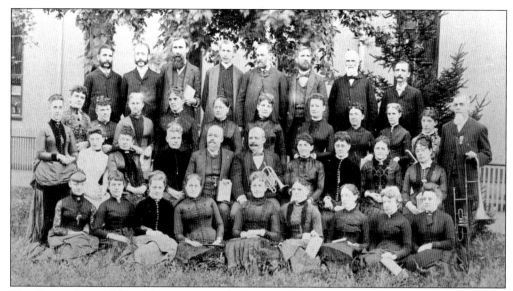

The Ocean Grove Choir of 1887 surrounds the director, Prof. J. R. Sweney, seated center with his hand on a hymnal. Professor Sweney led the choir for approximately 20 years before illness forced him to retire in 1898. Tali Esen Morgan was then appointed director and continued until 1915. (Courtesy Betty Polhemus.)

It was necessary for the front of the Auditorium to be enlarged to make room for the new Hope Jones organ, which was installed in 1908 in memory of Bishop James Fitzgerald, the second president of the Ocean Grove Camp Meeting Association. The eight gothic windows were removed and the two urns in the front were relocated. Improvements have been made to the organ so that today the 146-rank Great Auditorium organ is considered one of the truly fine concert instruments in the country. (Courtesy Betty Polhemus.)

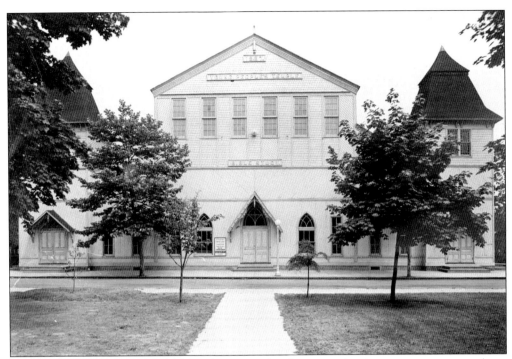

Attendance at the Young People's Temple increased to the extent that it was necessary to tear down the old 300-seat building to erect a larger structure. In 1889, plans were drawn by Maj. John C. Patterson, chief of police, for a new temple measuring 80 by 100 feet. The seating capacity was 1,500 people and cost $7,500. (Historical Society of Ocean Grove.)

Major Patterson was a person of many talents, serving as chief of police and superintendent of the Ocean Grove Camp Meeting Association. He designed and supervised the construction of the Youth Temple. He also laid the foundation of the Great Auditorium and oversaw the construction of the boardwalk. He received the highest honor medal awarded by Congress for his duties in the Life-Saving and Coast Guard Service by the "saving [of] life from the perils of the sea." (Historical Society of Ocean Grove.)

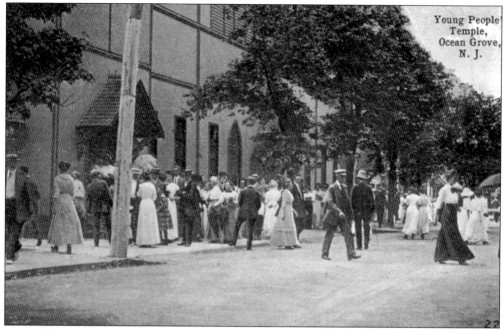

Two of the early youth leaders of Ocean Grove were C.H. Yatman and Tali Esen Morgan. Yatman would start the Young People's Temple meeting precisely at 9 a.m. every day by saying, "Good Morning, the sunshine hour has begun. Let us stand." In response, one thousand voices would break forth, singing, "Praise God from Whom all blessings flow." (Historical Society of Ocean Grove.)

The Young People's Temple was destroyed by fire on June 7, 1975. In 1999, the Ocean Grove Camp Meeting Association raised over $1 million to rebuild the temple for the next generation of youth. (Courtesy Judy Ryerson.)

For many years, the 8-foot-high sheet-metal letters on top of the Auditorium read, "Ocean Grove." They were removed in 1986 due to their poor structural integrity because of salt air corrosion. The O and G were rescued from the scrap heap by several youths (led by Cindy Bell and Scott Davenport), who carried them to the Ocean Grove Camp Meeting Association garage. (Historical Society of Ocean Grove.)

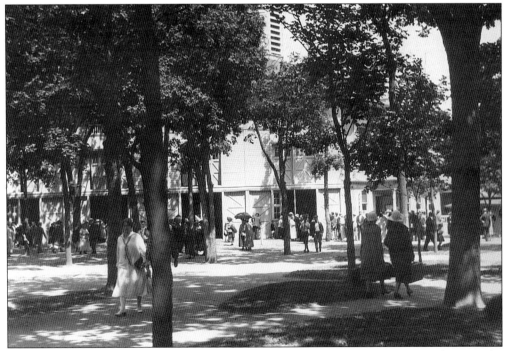

The Auditorium Park on a Sunday morning after services is always full of worshipers. The Ocean Grove Camp Meeting Association had achieved a balance between this new massive building and creating the feeling of a forested glen. (Historical Society of Ocean Grove.)

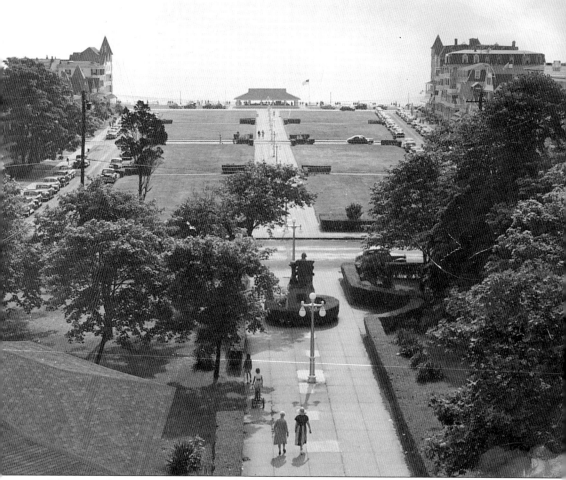

The vista from atop the main Auditorium tower, looking east toward the ocean, provides a wide view of Ocean Pathway. Both sides are flanked by large hotels with a mix of single-family homes. Ocean Pathway is one of the most photographed scenes by visitors. The Rev. E.H. Stokes monument in front of the Great Auditorium was dedicated on July 31, 1905. Paul W. Morris, a sculptor, cast a bronze heroic-sized form of Reverend Stokes sitting in a chair looking east toward the sea. Participants at the unveiling included New Jersey governor E.C. Stokes, a distant cousin, Bishop Spellmeyer, and A.H. DeHaven, Esq. (Historical Society of Ocean Grove.)

Four
CHANGING SCENES

The shell circle was a very popular postcard to send to friends back home. The publishers would place various scenes within the center. (Courtesy Judy Ryerson.)

Taliesen Morgan was born on October 28, 1858, in Wales at Llangynwyd Glamorganshire. In 1897, after a successful career in conducting in New York City, he came to Ocean Grove to take charge of the adult and children's choirs for a concert to be presented in the Great Auditorium by Walter Damrosch. Morgan became the musical director in 1898. His programs of festival choruses, pageants, and carnivals, filled the Great Auditorium with casts of hundreds. Other featured artists included Enrico Caruso, Anna Case, Mme. Schumann-Heink, and John McCormack. Morgan split his first name at the urging of Damrosch to Tali Esen. Homer Rodeheaver, to the right, is a fellow conductor. (Historical Society of Ocean Grove.)

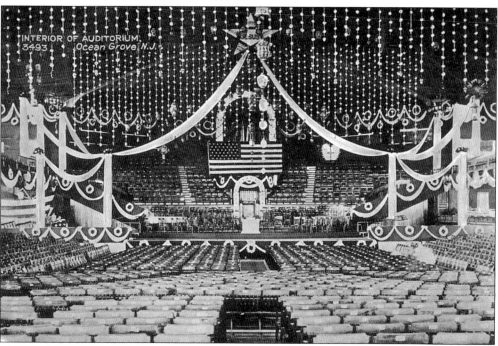

The Auditorium was richly decorated when a Tali Esen Morgan concert was presented. It was Morgan's insight that led to the development of the Rough Rider Brigade for the boys in Ocean Grove. Dressed in the Spanish-American War uniform of the day, the boys divided into companies, practiced military drills, paraded to their own music, learned military maneuvers, and bivouacked on the floor of the Auditorium.

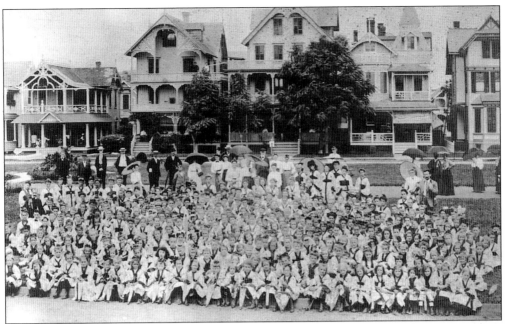

The children's chorus is sitting on Ocean Pathway for its 1904 picture. Morgan is standing to the right. The two residences behind the trees are now the Manchester Hotel. (Historical Society of Ocean Grove.)

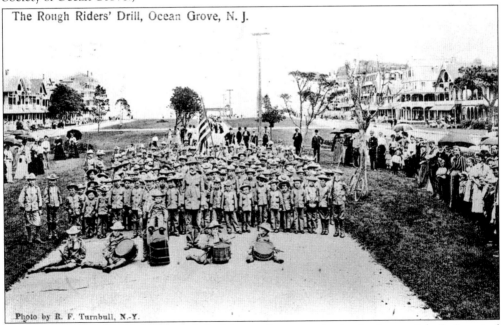

Nearly 1,000 voices were drilled daily by Morgan for six weeks, beginning on July 5. A typical chorus was composed of about 700 girls, divided into groups according to age and size. The boys, about 300 in number, were uniformed in Rough Rider suits. In the beginning, four Ocean Grove police officers were present to maintain order among the boys at choir rehearsal. It was Morgan's idea to form the boys into squads and companies of Rough Riders. No policemen were then needed. (Courtesy Judy Ryerson.)

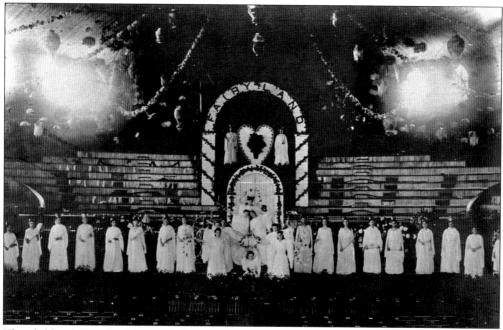

The children's Fairyland Festival always attracted a full audience. Hundreds of brightly colored Chinese lanterns illuminated a background of rocks and mountains, forests, ravines, and caverns, from which appropriately dressed Kimono girls would emerge to sing and dance for Queen Mab at the royal court. The highlight would be the coronation with ladies-in-waiting, flower maids, knights, and pages. (Courtesy Judy Ryerson.)

Morgan was able to bring to the Great Auditorium the newest and best musical talents of the 1910–1920 period. Performing at Ocean Grove was considered by many a necessary step to national recognition. While Enrico Caruso did not need such a step, his performance filled the Great Auditorium. (Courtesy Judy Ryerson.)

John Philip Sousa and his band is another example of the Saturday entertainment at the Great Auditorium. Others include the U.S. Army, Marine, and Air Force bands and the Ocean Grove summer band led by Harry Eichhorn. Sunday preachers have included Billy Sunday, Gypsy Smith, Williams Jennings Bryan, T. DeWitt Talmadge, Booker T. Washington, Billy Graham, Robert Schuller, Tony Campolo, and Norman Vincent Peale. (Courtesy Judy Ryerson.)

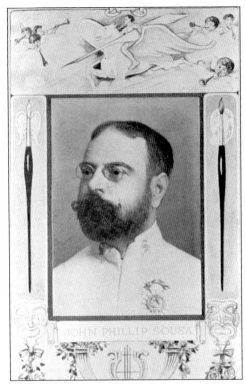

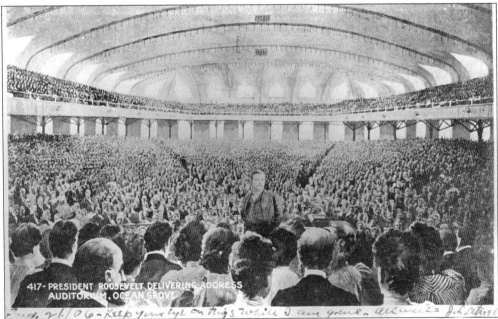

Pres. Theodore Roosevelt gave an address at the Convention of the National Education Association in the Great Auditorium on July 7, 1905. As he entered the audience, President Roosevelt received the Ocean Grove salute of waving a white handkerchief. This salute has become a tradition at the close of Camp Meetings when everyone sings "God Be with You Till We Meet Again." (Courtesy Judy Ryerson.)

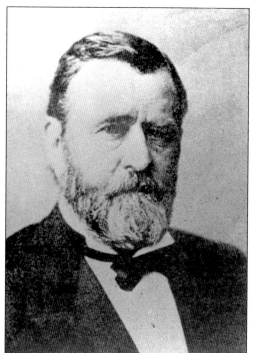

President Ulysses S. Grant visited Ocean Grove several times by invitation and to see his sister, who lived on Lake Avenue. His last public appearance was at the Reunion of the Army Chaplains in 1884 in Ocean Grove. Dr. A.J. Palmer, who introduced Grant, finished his remarks by saying, "And no combination of Wall Street sharpers shall tarnish the lustre of my old Commander's fame for me." Grant was too overcome with emotion to acknowledge the thunderous ovation and retired without a word. (Courtesy James Lindemuth.)

A few years before he was elected president, the congressman James A. Garfield spent an entire summer in Ocean Grove. President Garfield was shot in Washington, D.C., on July 2, 1881, by a disgruntled office-seeker. He died on September 9, 1881, at Elberon, New Jersey. His doctors had hoped that the New Jersey shore climate would arrest the infection in the wound. (Courtesy Judy Ryerson.)

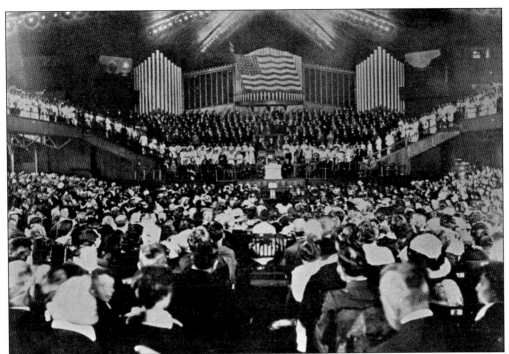

In the spring of 1914, the evangelist Billy Sunday held a major revival campaign among the various churches in the industrial city of Paterson, New Jersey. A choir of over 1,000 people was organized to perform in the evening song and preaching services. In 1915 this choir, the Paterson Tabernacle Choir, under the direction of James T. Jordan, was invited to participate in the August 21 Camp Meeting Day in Ocean Grove. Two long special trains were engaged to transport the choir and their friends from Paterson to Ocean Grove for a day of song and preaching. Today, the Annual Choir Festival, which attracts nearly 1,500 singers on the second Sunday of July, still fills the Great Auditorium. (Historical Society of Ocean Grove.)

Billy Sunday held a revival for nine days at the Great Auditorium in August 1916. Homer A. Rodeheaver led the evangelistic music as he had for the last seven years of the Billy Sunday campaigns. A free will offering amounted to $6,076.91, which Billy Sunday used to buy a home in Ocean Grove for an old minister who had been his valued friend and evangelistic associate. (Courtesy Betty Brown.)

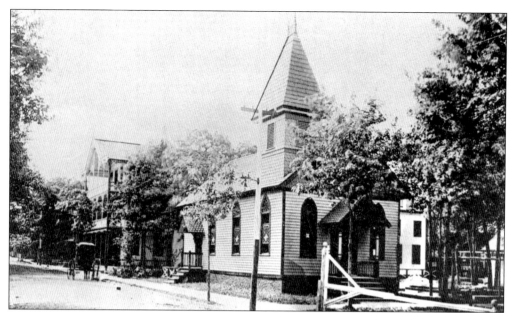

Rev. Joseph H. Thornley, one of the original charter members of the Ocean Grove Camp Meeting Association, had always talked about the need for a place suitable for smaller meetings. Thornley died February 12, 1889, in London, Ontario, Canada. Shortly thereafter, a committee was formed to raise funds for a Thornley Memorial Chapel. The building on the northwest corner of Mount Tabor Way and Pilgrim Pathway, owned by the association, was remodeled and dedicated on Sunday, June 30, 1889. The cost of the improvements with furniture, organ, and windows was $1,299.58, all of which was raised by donations.

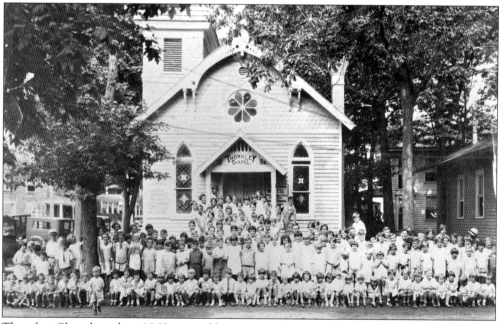

Thornley Chapel, with a 1960 rear addition, now hosts weddings, religious services, small meetings, and during the summer, the children's daily Bible school. This picture of third generation Ocean Grove children was taken in 1925.

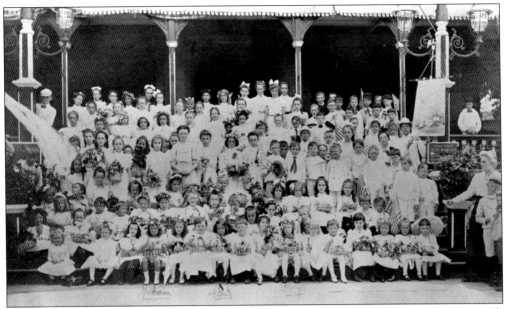

The music program at Thornley Chapel was for many children a first time experience with both classical and contemporary works. Strong emphasis was placed on religious hymns. The children are assembled on the Arlington porch for a group picture before their performance in the Auditorium. (Historical Society of Ocean Grove.)

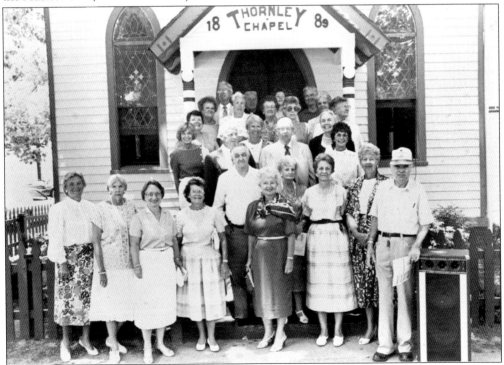

These faces are just as eager as the children's faces were some 50 years before. This was part of the 100-year celebration of Thornley Chapel in 1989, when a group of "old timers" got together. (Historical Society of Ocean Grove.)

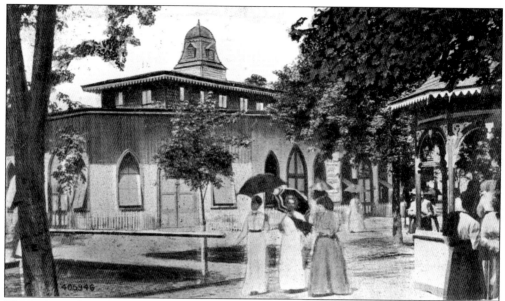

The Bishop Edmund Janes Memorial Tabernacle was dedicated on July 14, 1877. The eight-sided timber-framed building seats around 350 people. The small mansard-style four-sided cupola centered on top of an elongated clerestory rectangular structure was removed due to storm and rain damage. The first floor gothic windows, set on both sides in iron pins, can be tilted open for cooling sea breezes. A system of ropes and pulleys operate the upper clerestory windows. Since its dedication, a devotional Bible hour is held here from 9 to 10 each morning during the summer season. The Beersheba well is to the right.

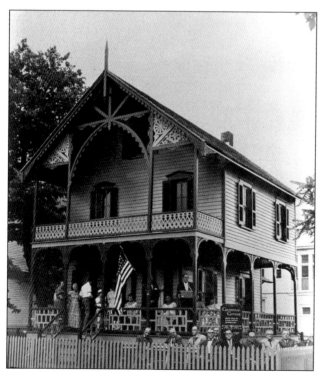

Centennial Cottage, built in 1874, is a carpenter's gothic style cottage maintained as a museum by the Historical Society of Ocean Grove. It is open to the public during the summer. The building was purchased by the Robert Skold family and donated to the Ocean Grove Camp Meeting Association. A Victorian garden adjoins the cottage located at Central Avenue and McClintock Street. (Historical Society of Ocean Grove.)

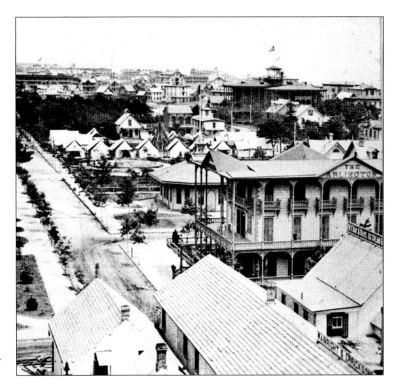

The octagonal, single-story structure (center) with a cupola and flagpole was removed so a new and larger youth temple could be constructed. This octagon was the first "Youth Temple" in Ocean Grove and seated about 300 people. The brick building used for tent storage is behind the flagpole. The trees, evenly spaced along Pilgrim Pathway, are the result of President Stokes's constant emphasis on the "grove" part of Ocean Grove. (Historical Society of Ocean Grove.)

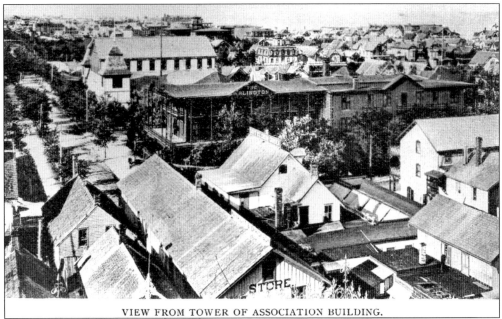

VIEW FROM TOWER OF ASSOCIATION BUILDING.

The growth of Ocean Grove is evident in this picture taken from the tower of the Ocean Grove Camp Meeting Association building. Across from the Arlington Hotel is the Days' Ice Cream Garden sign on the peak of the roof. The garden awnings are to the right. The Youth Temple has been built in this 1887 photograph. The Sheldon House cupola can be seen in the far center. (Historical Society of Ocean Grove.)

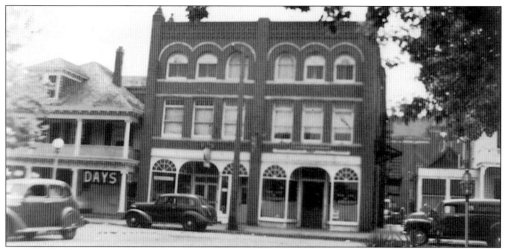

In 1889, the old wood frame building on Pilgrim Pathway that had housed Wainwright and Errickson's general provision store was torn down. A large three-story brick building, measuring 44 by 105 feet with a height of about 33 feet, was erected on the vacated lots. The total cost was $11,657. This improvement allowed Mr. White's drug store and Mr. Goodheart's meat, fish, and oyster store to be incorporated into the new building. The cold storage locker is still in the basement. There are now three businesses and the museum of the Historical Society of Ocean Grove on the ground floor. Condominium apartments occupy the upper floors. (Courtesy of James Lindemuth.)

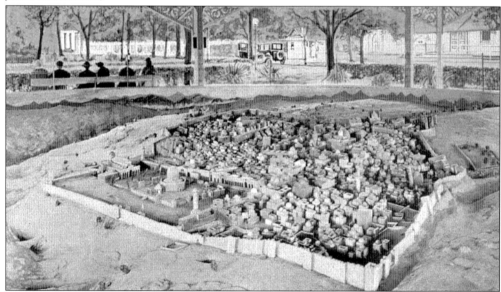

A model of Jerusalem was presented to the Ocean Grove Camp Meeting Association in 1881. The Reverend W.W. Wythe, M.D., a resident of Ocean Grove, had first shown the model at the Chautauqua Camp Meeting Grounds in 1874. For various reasons, Wythe decided that Ocean Grove was a more appropriate location. This miniature representation of the Holy City with its streets, dwellings, mosques, and minarets was a favorite attraction to visitors at Ocean Grove. An eight-sided pavilion was built over the model as a protective measure. In the early 1950s, the model was removed for repairs, but the project was abandoned due to unfortunate circumstances. (Historical Society of Ocean Grove.)

The Ocean Grove Camp Meeting Association's business had increased to the extent that a larger, more suitable building was necessary. A contract for a three-story, 65-square-foot brick building with a basement was given to a Mr. Buck of Brooklyn, New York. The original estimate of $15,000 proved to be low; the final cost was $22,000. The cost overrun included a tower clock, a bell, an eight horsepower engine, a well, outside roof cresting, furniture, gas fixtures, plumbing, and post office fixtures. This new building, housing the post office and the association, was begun in December 1880. It was completed and dedicated on Founders Day, August 1, 1881. Enough brick was left over that a new tent storage house was constructed on Bath Avenue. The tent building was two stories high and measured 22 by 30 feet. (Historical Society of Ocean Grove.)

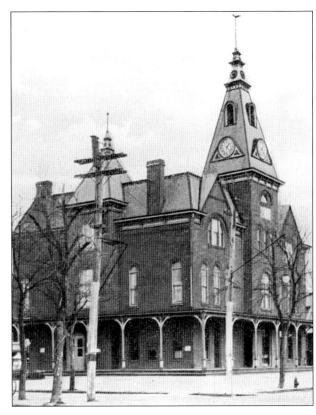

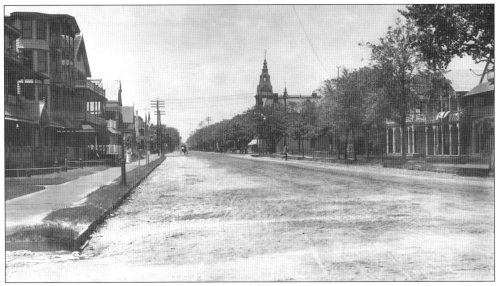

The intersection of Central and Main Avenues, looking west from Beach Avenue, shows a view of the Ocean Grove Camp Meeting Association building with its decorative tower and clock. Two horse carriages and two people are the only evidence of human activity. Slate curbing, grass strips, and trees line both sides of Main Avenue west from Central Avenue. Simple pipe fences separate individual properties. (Historical Society of Ocean Grove.)

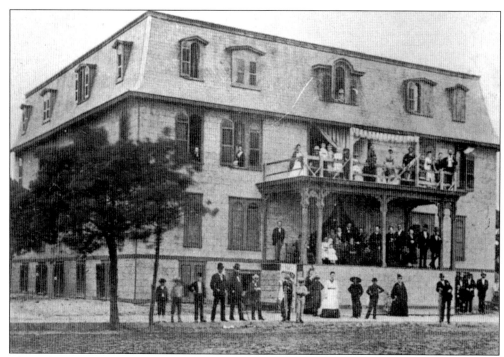

The Arlington Hotel was one of the grand hotels in Ocean Grove. Located directly across from Auditorium Park, it occupied an entire block. The three-story hotel with a mansard roof provided a large number of rooms for summer vacationers. (Historical Society of Ocean Grove.)

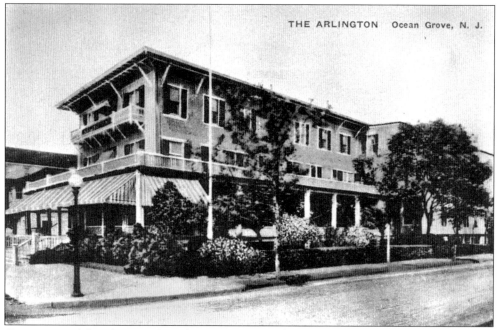

Comparison of this photograph to the previous one indicates how much the hotel changed over 60 years. In the 1950s, the hotel was razed and replaced by the first shore area cooperative, or condominium. (Historical Society of Ocean Grove.)

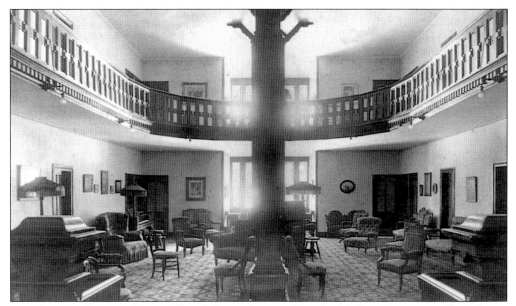

Two large parlors in the middle of the Arlington Hotel added to its sense of grandness. Dr. Frank Cooper, owner in the 1930s and 1940s, said that this parlor with balcony rooms was patterned after the Hudson River Day Line. The sitting room was furnished with overstuffed Victorian chairs and sofas. (Courtesy Judy Ryerson.)

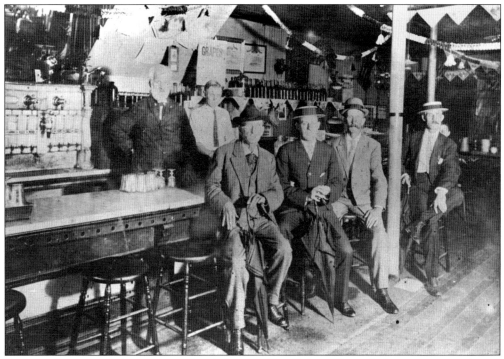

Four gentlemen with hats pose at the Arlington Hotel's bar. The only beverages served were coffee, tea, lemonade, and soda phosphates of all flavors. The lad behind the man on the far right is probably being treated to his first drink at a bar. (Courtesy Judy Ryerson.)

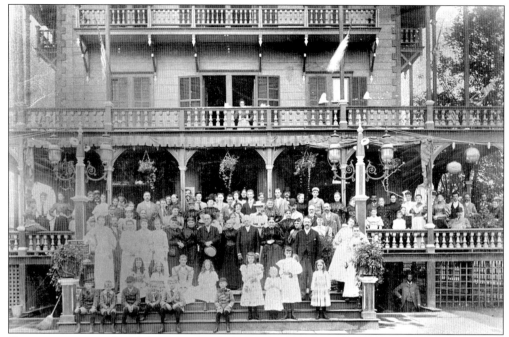

Group pictures at the Arlington Hotel were taken on special occasions, such as a family gathering, funeral, birthday, or christening. In this photograph, plants can be seen hanging between the porch columns. Wooden decorative quoins are evident at each corner on the first and second sleeping floors. (Neptune Museum.)

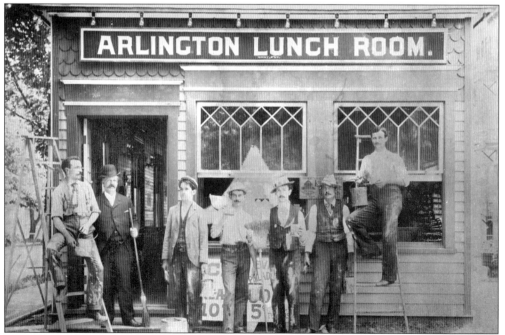

The Arlington Lunch Room, where sandwiches and other items were available, was adjacent to the main dining room. These six individuals appear to have more paint on their clothes than on the building. It is not difficult to determine who is the boss. (Courtesy Judy Ryerson.)

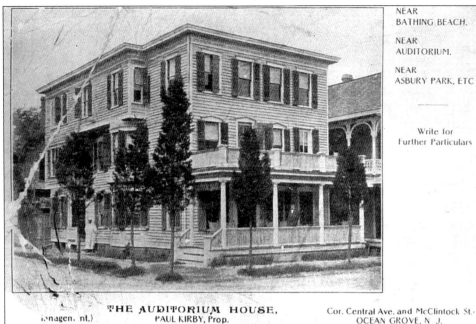

The Auditorium House, now the Central Avenue House, is another example of a hotel that has been in a family for several generations. It was originally purchased in 1899 for $1,000 by Cora Mae (Burr) Applegate. Cora Mae's favorite place was on a porch rocker talking to guests. When people came for rooms, she would just wave them in and say, "Pick any room that's open. We're just camping out here!" (Courtesy Jennifer Sirois.)

The addition of third-floor bedrooms over an existing porch was a common response to the increased demand for accommodations. (Courtesy Jennifer Sirois.)

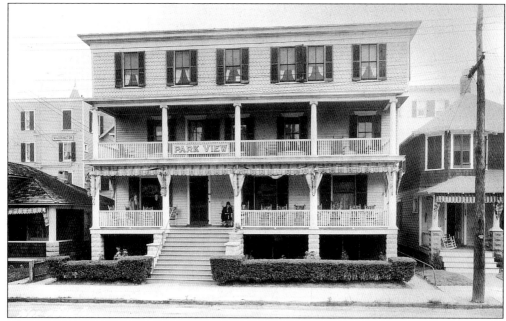

The Park View Hotel on SeaView Avenue was managed for 74 years by the same family, the Wainrights and the Hemphills. Every fall, the water pipes would be drained, and the shutters would be closed. In the spring, the process would be reversed. Many visitors lodging at the hotel formed long-term friendships that continue today.

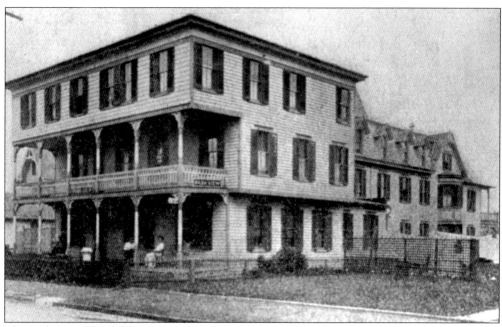

The Park View Hotel, like many others in town, was originally a ground-level structure. As the demand for rooms increased, these structures were raised one level, and lodging for summer help was added in the new, cooler basement. (Courtesy Judy Ryerson.)

Five
GRAND HOTELS

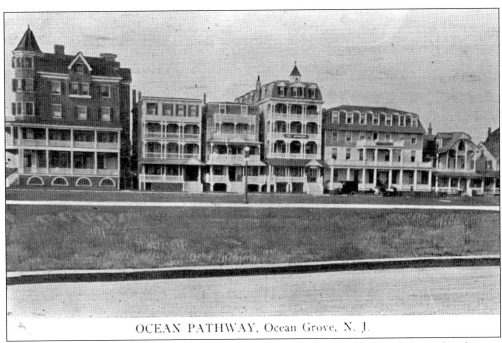

OCEAN PATHWAY, Ocean Grove, N. J.

This chapter shows the hotels in Ocean Grove from 1885 to 1920. Throughout the chapter, the name of the hotel, its location, the owner or manager, and the hotel's capacity are listed below each picture. Many of the original hotels are not pictured, since early photographs have not yet been found. At one time, there were more than 5,000 rooms available at 110 hotels and lodgings in Ocean Grove. The five hotels above, beginning with the Majestic on the far left to the DunHaven, were all destroyed by a fire in December 1977. Thirty-five engines from 13 surrounding towns were required to prevent the conflagration from spreading. (All hotels in chapter 5 courtesy Judy Ryerson.)

73

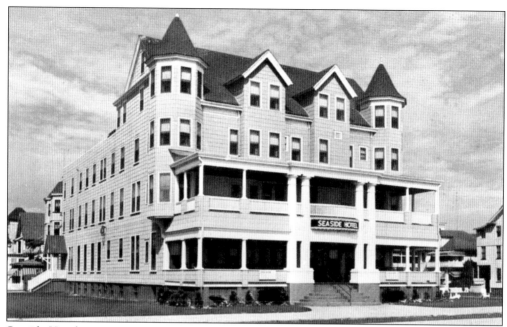

Seaside Hotel.
Ocean and SeaView Avenue.
C. G. Stockton.
200-person capacity.

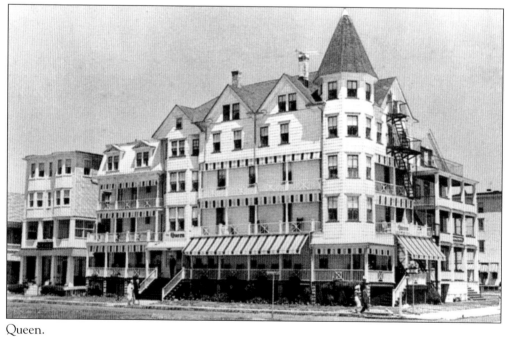

Queen.
1 Ocean Pathway.
L. J. Russell.
100-person capacity.

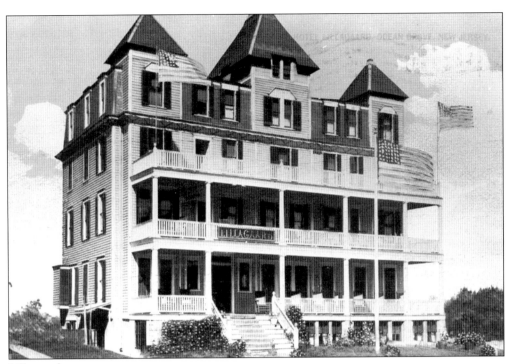

Lillagaard.
5 Abbott Avenue.
L.D. Pennwarden.
100-person capacity.

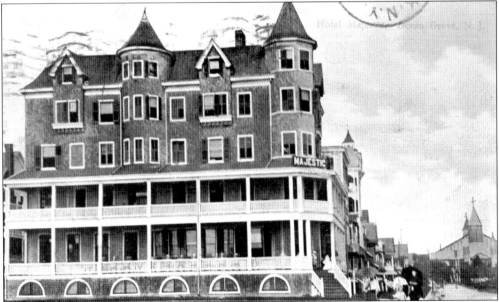

Majestic.
2 Ocean Pathway.
E. Clement.
200-person capacity.

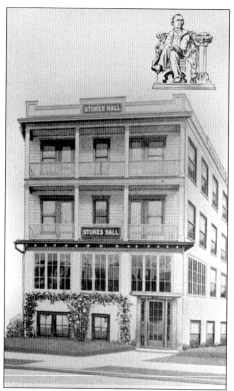

Stokes Hall.
28 Ocean Pathway.
A.L.E. Strassburger.
125-person capacity.

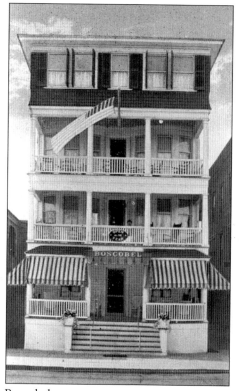

Boscobel.
68 Main Avenue.
M.L. Bioren.
75-person capacity.

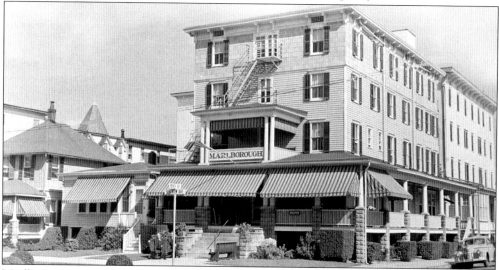

Marlboro.
17 SeaView Avenue.
S.B. Lippincott.
250-person capacity.

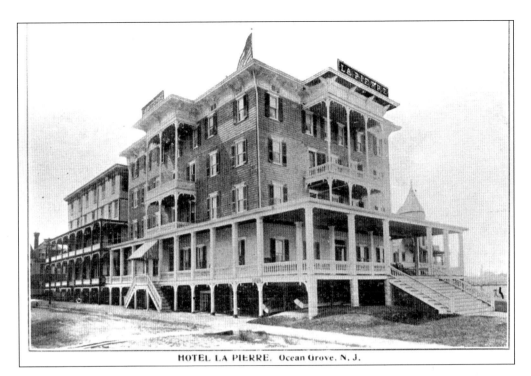

Hotel La Pierre.
Spray and Beach Avenue.
R.M. Watt.
250-person capacity.

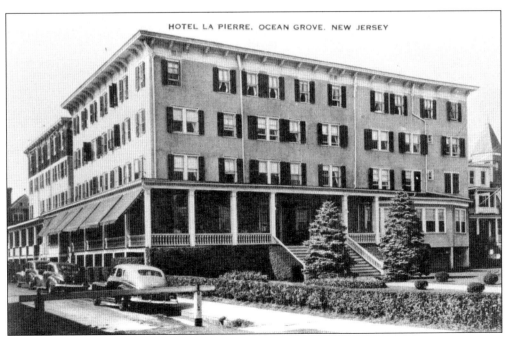

The La Pierre's expansion to the right was typical of successful hotels.

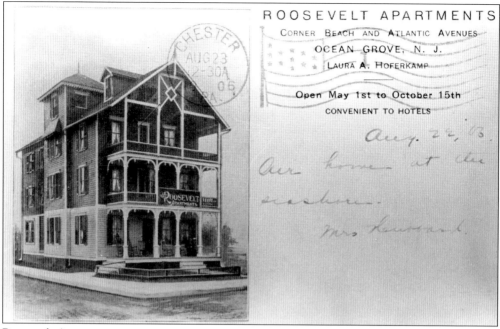

Roosevelt Apartments.
Beach and Atlantic Avenue.
L.A. Hoffercamp.
40-person capacity.

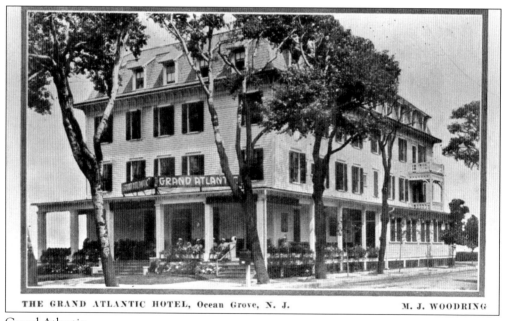

Grand Atlantic.
21 Main Avenue.
M.J. Woodring.
200-person capacity.

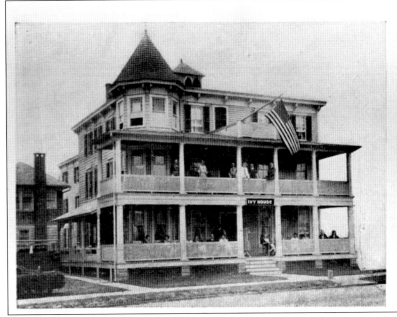

Ivy House.
24 Main Avenue.
A.M. VanSkite.
100-person capacity.

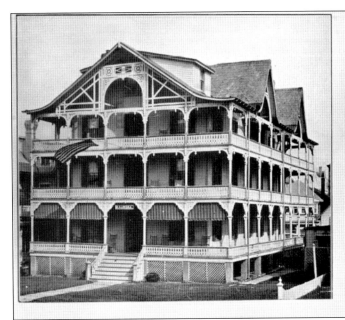

The Aurora.
5 Surf Avenue.
L.H. Bull.
90-person capacity.

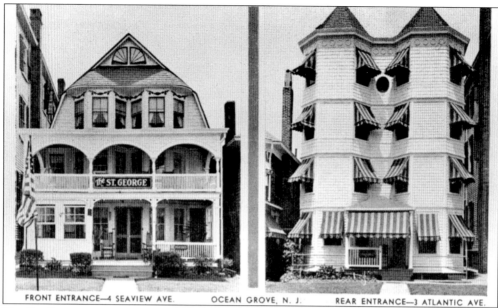

The St. George.
4 SeaView Avenue and 3 Atlantic Avenue.

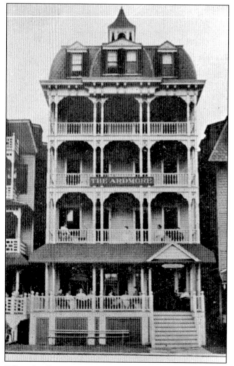

The Ardmore.
8 Ocean Pathway
E.K. Shaw.
100-person capacity.

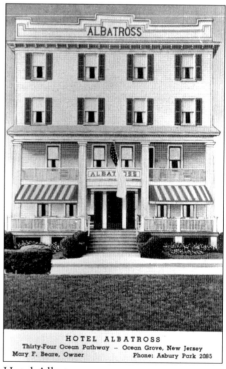

Hotel Albatross.
34 Ocean Pathway.
L.C. Brown.
125-person capacity.

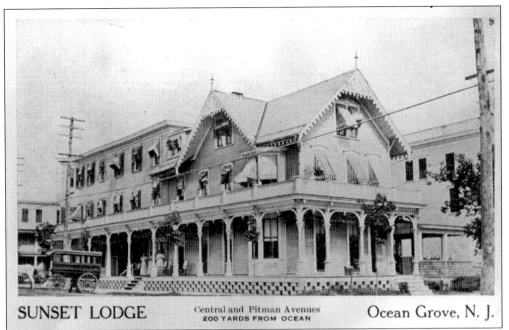

Sunset Lodge.
Central and Pitman Avenue.
J.B. Sweet.
100-person capacity.

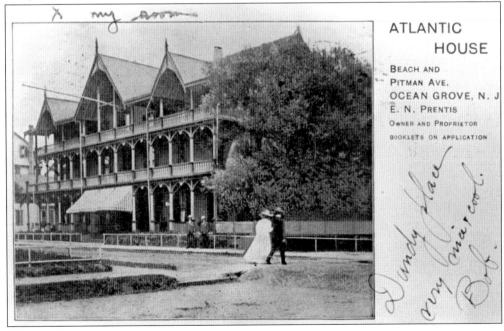

Atlantic House.
Beach and Pitman Avenue.
C.A. Agassiz.
100-person capacity.

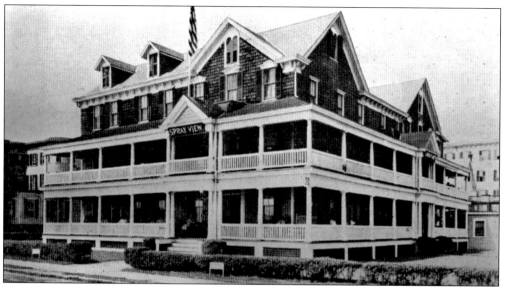

Hotel Spray View.
Ocean and SeaView Avenue.
L. White.
150-person capacity.

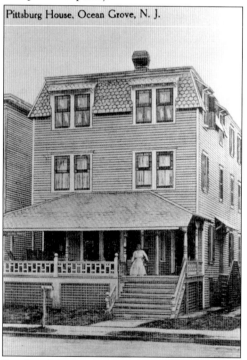

Pittsburgh House.
Location and statistics unknown.

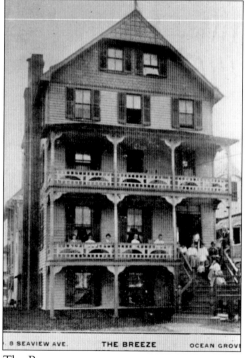

The Breeze.
8 SeaView Avenue.
R.C. Evans.
90-person capacity.

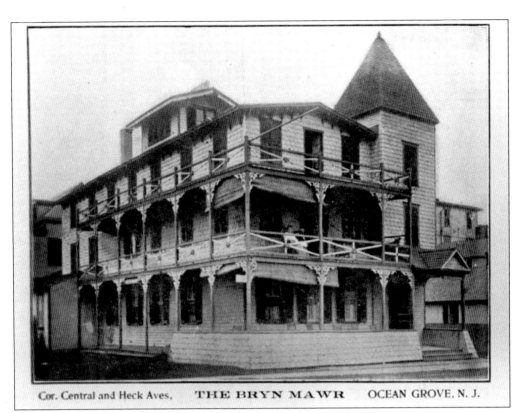

Bryn Mawr.
Central and Heck Avenue.
J.B. Sherman.
60-person capacity.

Diamond State.
The ocean end of
Embury Avenue.
M. Everngam.
50-person capacity.

Kenilworth.
Lake Avenue and Founders Park.
Fullwood and Tolson.

Ocean Side.
25 Ocean Avenue.
F.H. Kunst.
60-person capacity.

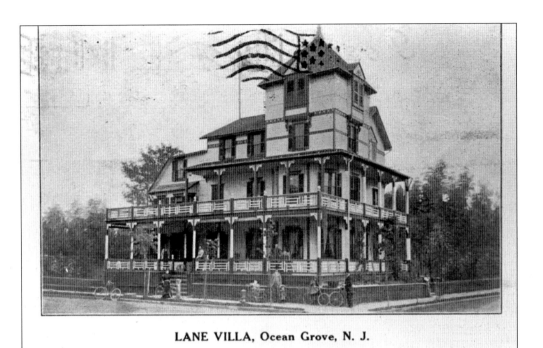

LANE VILLA, Ocean Grove, N. J.

Lane Villa.
63 Cookman Avenue.
M.L. and L.A. Lane.
60-person capacity.

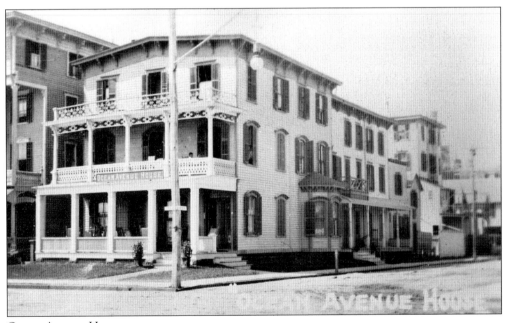

Ocean Avenue House.
Ocean Avenue and Olin.
A.F. Griffin.
85-person capacity.

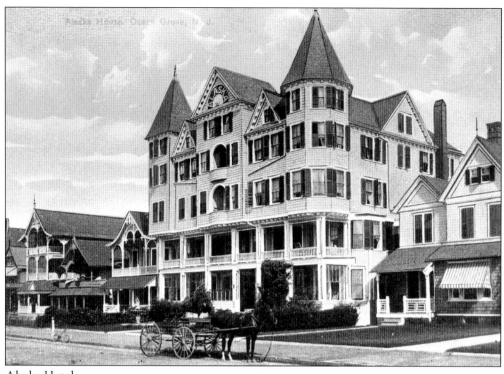

Alaska Hotel.
5 Pitman Avenue.
Alaska Hotel Corporation.
200-person capacity. (Destroyed by fire, January 24, 1919.)

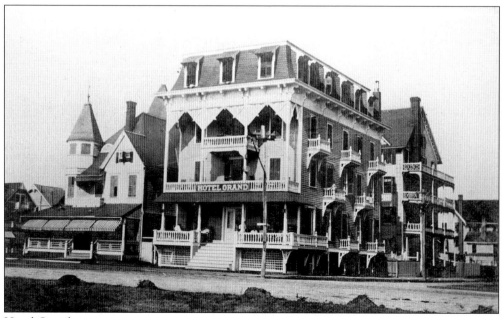

Hotel Grand.
13 Ocean Avenue.

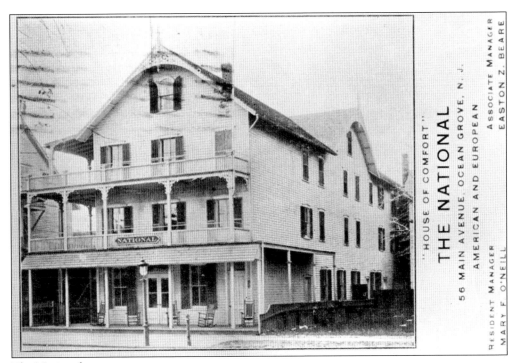

The National.
56 Main Avenue.
Statistics unknown.

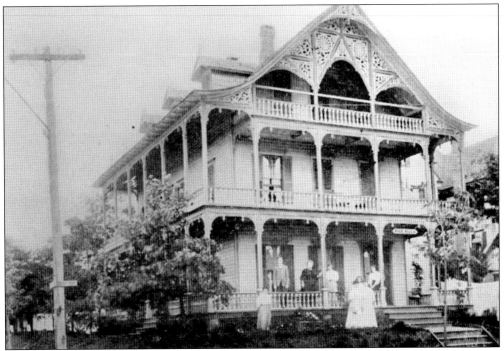

The Rice Villa.
Location and statistics unknown.

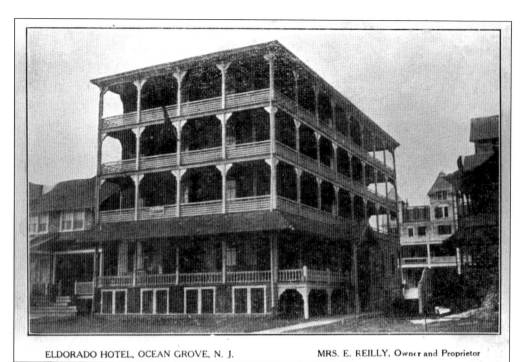

ELDORADO HOTEL, OCEAN GROVE, N. J. MRS. E. REILLY, Owner and Proprietor

The Eldorado.
5 Broadway.

EAT AT
The Eldorado Hotel and Cafeteria
RATES EUROPEAN

	June 1 to 30 Labor Day to Oct. 15				July 1 to Labor Day			
	SINGLE ROOM		DOUBLE ROOM		SINGLE ROOM		DOUBLE ROOM	
PRICE PER ROOM	Day	Week	Day	Week	Day	Week	Day	Week
Third Sleeping Floor	$1.50	$ 8.00	$2.00 up	$12 up	$2.00	$12.00	$3.00 up	$20 up
Second Sleeping Floor	1.75	10.00	2.50 up	15 up	2.50	15.00	4.00 up	25 up
First Sleeping Floor	2.00	12.00	3.00 up	20 up	3.00	18.00	5.00 up	30 up

Cots in rooms, $3.00 per week extra. Telephone, Asbury Park 2027.

All outside rooms. Hot and cold running water in every room.

MRS. E. REILLY.

The rates for rooms and food are typical of the 1900 era.

Six
BOARDWALK-BY-THE-SEA

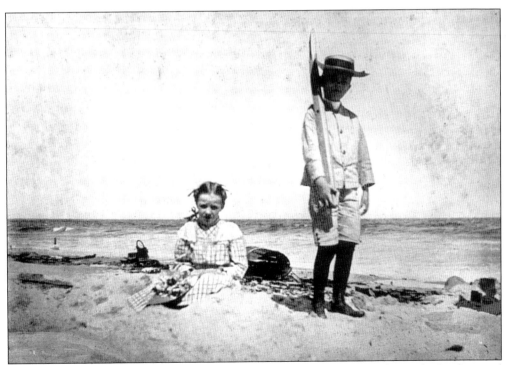

A young soldier boy patrols the beach while his younger sister plays in the sand. Her dress and his button coat are typical of the 1910 period. (Courtesy William Kresge.)

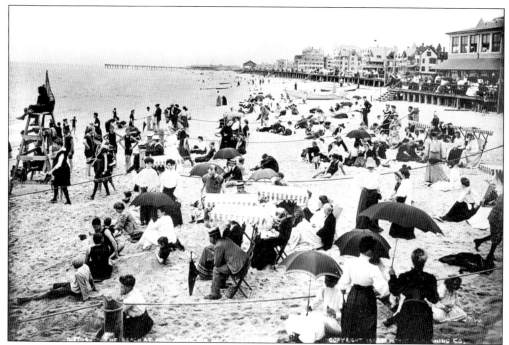

The beach at Ross Pavilion in 1905 is a mixture of swimmers and sunbathers. It may be a hot day, as is suggested by the open umbrellas. On the other hand, it might be a cold day, as the people under the striped awnings are wrapped in blankets. (Historical Society of Ocean Grove.)

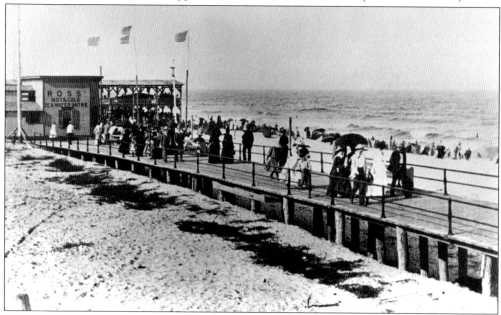

The boardwalk consisted of 3,100 feet of planks laid on the sand between the Ross and Lillagore Pavilions. For the first few years, the boards were taken up in the fall and stored for use the following spring. This practice was abandoned when a more substantial piling and under-frame base was constructed. The boardwalk in the picture is estimated to be 12 feet wide. Hot and cold seawater baths are advertised on the wall. (Historical Society of Ocean Grove.)

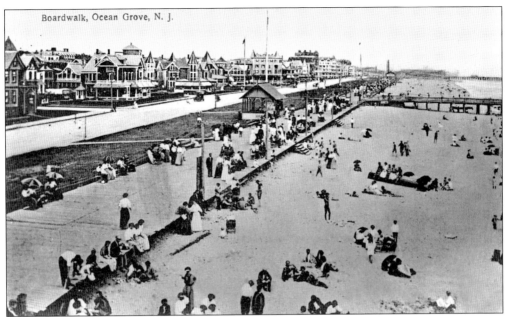

Boardwalks were for walking and enjoying the healthful benefits of the salt air. The fishing pier extended some 500 feet east from the boardwalk. This photograph is unusual because of the electric light poles and the absence of a railing along the boardwalk. Railings were installed in 1887. (Courtesy Ethel Hemphill.)

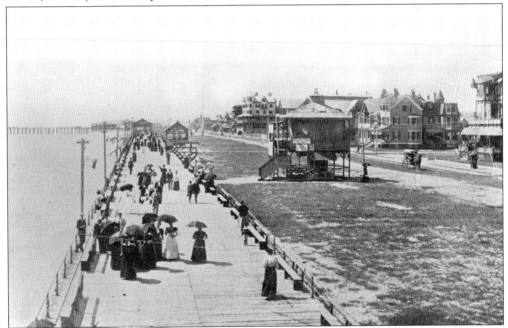

The widening of the boardwalk is evident in this 1903 photograph. The odd-looking structure in the center was called the *camera obscura*. Once viewers had climbed the stairs and entered a circular room, they visually experienced a 360-degree panorama of the outside surroundings projected onto the interior wall. The mirror-telescope system is at the top of the building. (Courtesy William Kresge.)

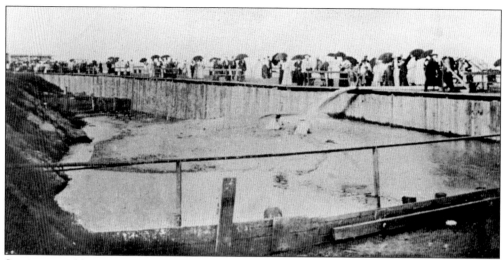

Storms caused big washouts along Ocean Avenue. A sand-seawater slurry is being pumped from the beach into a large washout area. Mentioned in one report was the destruction of the *camera obscura* at this site. (Historical Society of Ocean Grove.)

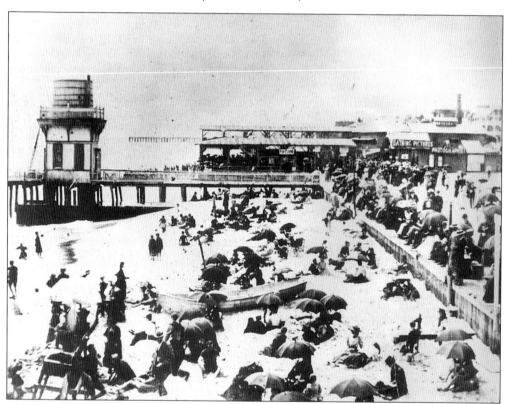

The Ocean Grove Camp Meeting Association was responsible for the streets in Ocean Grove. One of the problems of street maintenance was dust. The tower on the left is a device that pumped saltwater at high tide by a system of hinges and traps to the tank on the top. The seawater was then used to wet the streets. The project was not successful. (Historical Society of Ocean Grove.)

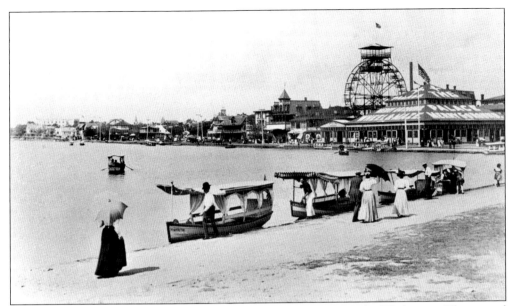

The first boat on the left, manned by a bowler-hatted oarsman, is the *Washington*. The second boat, with the striped awning, is the *Frolic*. At one time, there were over 175 boats of this type on the lake. The structure on top of the Ferris wheel, designed by Ernest Schnitzler, is an observation deck. The Crystal Maze building and the Palace Merry-Go-Round were popular attractions in Asbury Park. On Sundays, boat operators could not receive or discharge passengers on the Ocean Grove side of Wesley Lake. (Historical Society of Ocean Grove.)

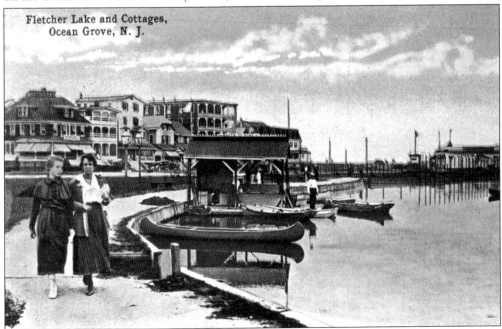

Fletcher Lake was the last area to be developed, although the Lillagore Pavilion on the beach was a major bathing area. It was a shorter walk for people living south of Main Avenue to use the South End bathing houses. The boat livery rented rowboats and canoes by the hour or by the day. (Courtesy Judy Ryerson.)

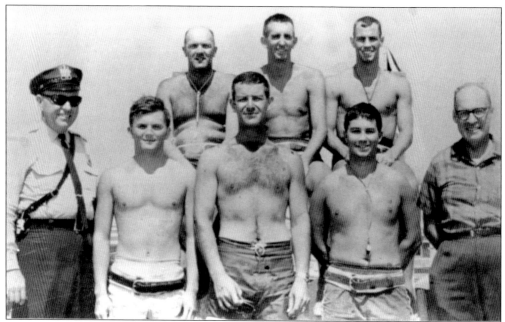

In the 1950s, the South End Beach was patrolled. Shown, from left to right, are the following: (front row) summer police officer Charles Jackson; lifeguards John Blewitt, Lou Mitchell, Otto Stoll III, and his father, bathing manager Otto G. Stoll Jr.; (back row) Harry Eichhorn, Dave Shotwell, and Richard Manley. (Courtesy William Kresge.)

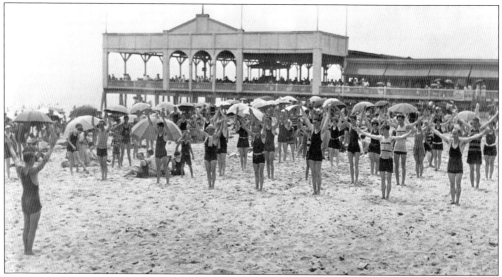

Activities at the beach, besides swimming, included sandcastle-building, crab-catching, shell-collecting, fishing, and group calisthenics, usually led by a handsome college lifeguard. Changes in bathing attire since the photograph was taken are obvious. The suits were made of wool and itched terribly when they were wet and full of sand. The pavilion complex at the east end of Fletcher Lake was developed by T.W. Lillagore, one of the early hotel owners in Ocean Grove. The South End Pavilion was gradually reduced in size by fires and coastal storms. All that remains now are scattered posts in the water along the north side of Fletcher Lake, where the changing lockers were located. (Courtesy Ethel Hemphill.)

For 117 years, carriages and cars were prohibited on Ocean Grove streets on Sunday. The red maple-lined Pilgrim Pathway presents a scene of peace and tranquillity. The wooden ramps extending into the pathway are for carriages and rolling chairs. This picture was probably taken in the fall, since the canvas tents are not set up in front of the wooden cabins. (Historical Society of Ocean Grove.)

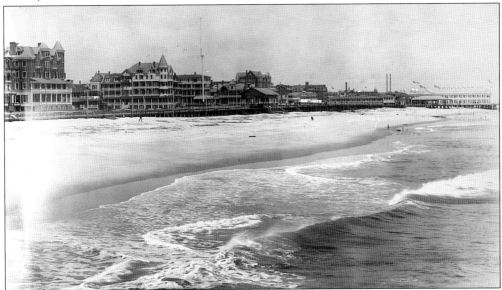

This vista of the beach and Ocean Avenue is very impressive. Several of the larger hotels are now gone due to fire. As the result of a sand replenishment project in 1999, the beach has been extended some 300 feet eastward, with the hope of reducing coastal erosion. (Neptune Museum.)

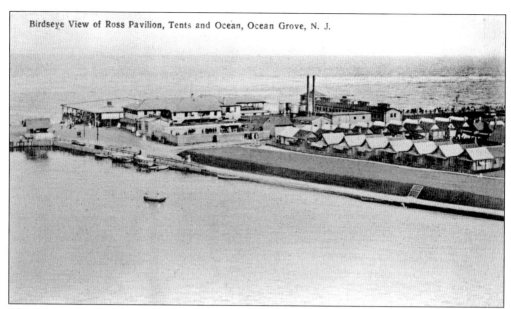

This bird's-eye view shows Ross Pavilion (left) before it was purchased by the Ocean Grove Camp Meeting Association. The tent village along Wesley Lake was eventually removed in order to fully develop the North End Complex. (Courtesy Judy Ryerson.)

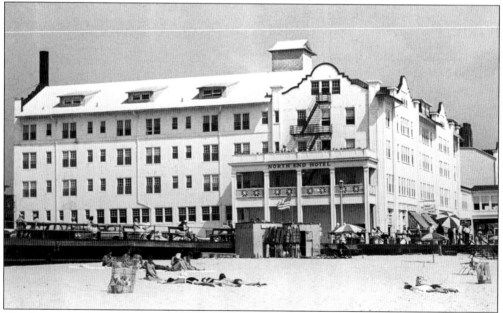

The five-story North End Hotel complex was completed by the Ocean Grove Camp Meeting Association in 1911. Its up-to-date attractions included the following: elevators, electric light and gas, 50 suites with private baths, a telephone in every room, fireplaces for chilly days, immense parlors, and the free use of the second story of the new pavilion to the east. Other additions to the complex included new bathing facilities, with an underground tunnel from the lockers to the beach, a swimming pool, four bowling alleys, a merry-go-round, a moving picture hall, new stores, and an immense dining room–cafeteria for the free use of excursionists. (Courtesy William Kresge.)

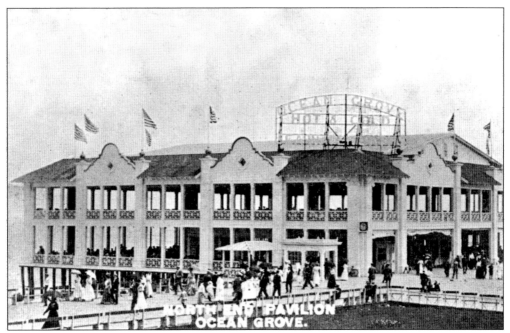
The North End Pavilion was a major financial undertaking for the Ocean Grove Camp Meeting Association in 1909–1911, but it was necessary in order for Ocean Grove to compete with other seashore locales. At night, the building was outlined in small white lights, as was fashionable at other resorts. (Courtesy Judy Ryerson.)

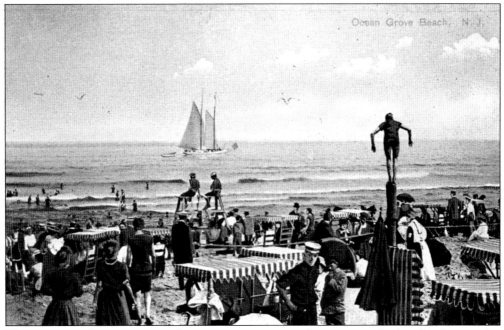
There is no explanation as to why one swimmer is standing on top of a beach piling in this photograph. Perhaps he was trying to impress his girlfriend. It looks like a long dive to the water. (Courtesy Judy Ryerson.)

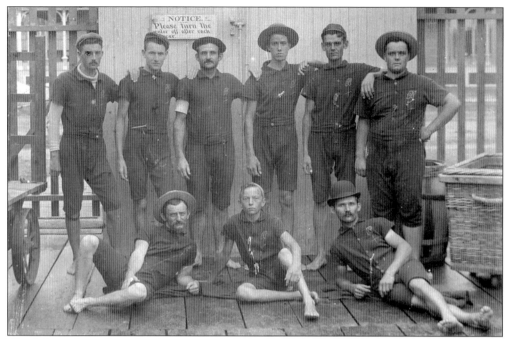

The lifeguards at Ross Pavilion were always willing to pose for group portraits, as in this c. 1902 photograph. Their wool bathing suits were buttoned down the front. The head coverings were an interesting collection of styles: a derby hat, a broad-rim straw hat, a yacht cap, and a U.S. cavalry hat. The notice in the rear reads, "Please turn off water after each shower." (Courtesy Ethel Hemphill.)

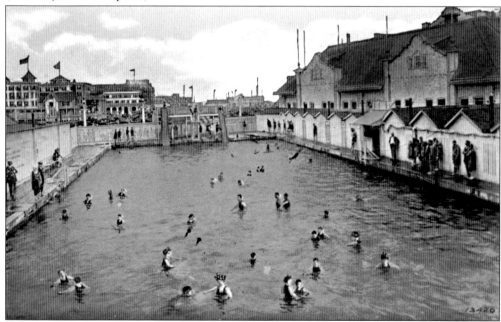

The North End pool had two water slides that were in constant use. Swimming lessons, later taught by Dr. Anna Nichols, were available in the 3-foot end of the pool. Swim meets were held with other town teams from up and down the New Jersey shore. (Courtesy Judy Ryerson.)

There was always a fierce rivalry between the North End and South End lifeguards. This led to competitions involving surf rescue with all types of aid equipment and both single-person and team efforts. It was a practice that was called on many times to rescue bathers in trouble. Today, towns along the New Jersey shore host summer lifeguard competitions at the beaches, often with 500 to 600 people cheering on their respective teams. Those shown in this 1950s picture are, from left to right, as follows: (front row) Clyde Hemphill, Augie Stoll, and Andy Leach; (back row) Bob Cooper, Dick Hennig, and Norman Klauder. (Courtesy William Kresge.)

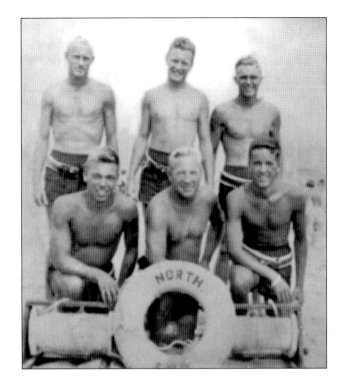

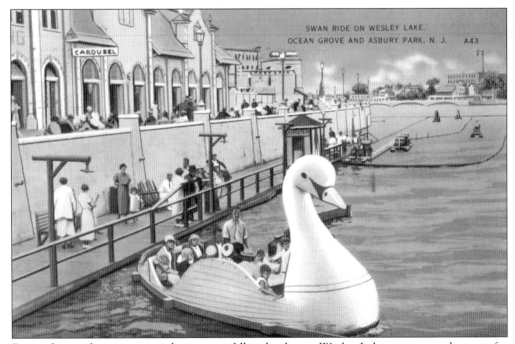

Boat rides on the swan or on the stern paddle-wheeler on Wesley Lake were annual events for vacationers. Other choices were two-seated paddleboats or motor boats located on the Asbury Park side. The swan has been adopted as the symbol of the Wesley Lake Commission in their efforts to restore the lake. (Courtesy Judy Ryerson.)

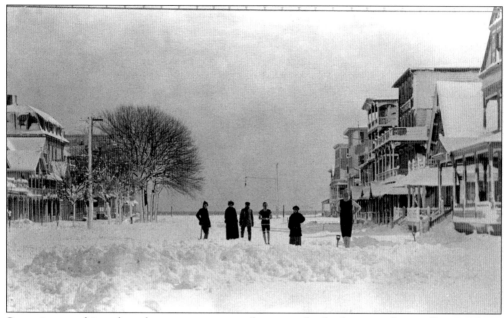

Snow is something that the summer visitor does not think about in Ocean Grove. These two hardy souls wearing bathing suits c. 1928 are busy having fun with the white stuff on a Sunday on Main Avenue. There are no cars to dig out of the snow banks. (Historical Society of Ocean Grove.)

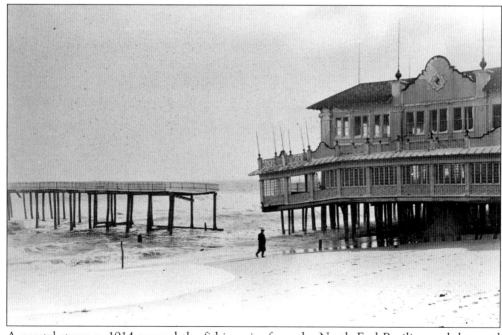

A coastal storm c. 1914 severed the fishing pier from the North End Pavilion and damaged the glass enclosed portico. The fishing pier was eventually destroyed in the Hurricane of 1938. (Courtesy Judy Ryerson.)

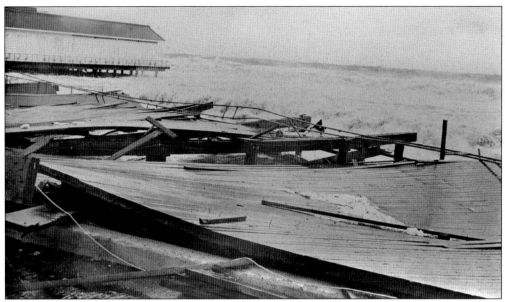

Coastal storms—either a northeaster or a hurricane—generally caused considerable damage to the boardwalk and to the North End and South End buildings. The storms also kept a few roofing contractors in business. The sand under the Homestead restaurant at the North End is being removed with each wave. By late summer, the sand would be back under the restaurant, carried in by beach winds. (Courtesy William Kresge.)

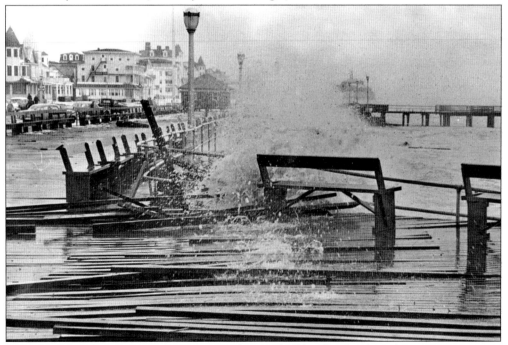

There is tremendous power in storm waves. The iron bulkhead at South End serves an important function, as this photograph illustrates. Sometimes, at storm high tide, entire 50-foot sections of boardwalk, shown on the left, would be lifted and carried west to the other side of Ocean Avenue. (Courtesy William Kresge.)

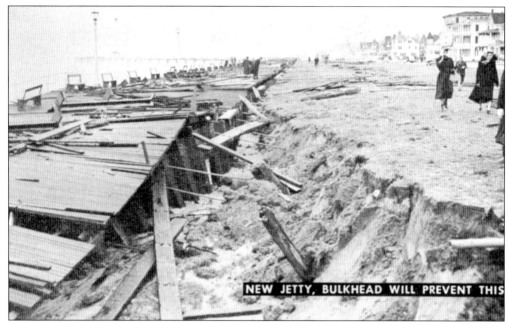

Hurricanes can destroy any structures within a close distance of the beach, as this picture illustrates. One violent storm pushed the North End Restaurant against the North End Hotel. After the storm, tables were found on the beach that were still completely set for dinner. (Courtesy Ethel Hemphill.)

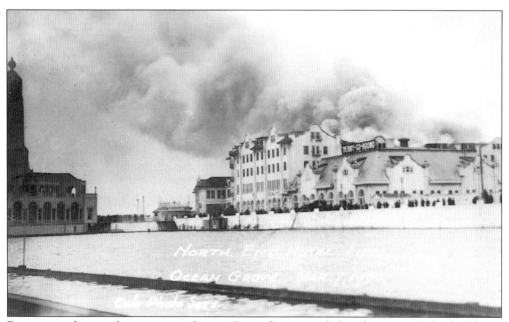

Fires were always of concern in Ocean Grove because of the closeness of the buildings, 99 percent of which were wood. This fire at the North End Hotel on March 7, 1938, required many outside fire companies to help extinguish the blaze, which caused an estimated $75,000 in damages. This view from the Asbury Park side of Wesley Lake shows that the amusement area and at least half of the hotel were not affected by the blaze. (Courtesy James Lindemuth.)

Modern inventions were generally embraced by the Ocean Grove Camp Meeting Association. Telegraph, telephone, gas, and electricity were quickly advertised in Ocean Grove literature. Moving pictures were usually shown in the Great Auditorium under a contract with an exhibitor. In 1911, the North End Hotel Complex provided a moving picture theater called the Scenario. The policy of the association required that only movies of an educational, moral, or clearly descriptive nature were presented. A censor was appointed by the association to screen all pictures shown in the theater. A fine of $100 was ordered if the exhibitor showed any moving pictures that were not approved by the censor. The Scenario was always closed on Sundays. The name of the theater was eventually changed to the Strand.

West from the Strand theater along Wesley Lake were other amusements, including a rifle gallery, bowling, skee ball, and a carousel. In skee ball, a nickel per game provided nine wooden balls that were rolled down the alley. Scores depended on the skill of directing the balls into the small holes in the center of the circles. Total points for free games were adjusted for men (210 points), women (180 points) and children (150 points). Vacuum cleaners kept the alleys in good condition.

This formal graduation picture shows Nettie M. Reed with her diploma, which is tightly rolled in her left hand. Her jewelry is very simple, with an armband watch, a pin, and a locket on a chain around her high-neck collar. The one-piece dress is accented with three matched lace bands. (Historical Society of Ocean Grove.)

Two ladies in white pose against a painted seascape backdrop. Their lampshade hats, wrapped in ribbon and lace, complement the cotton lace bands of the dresses and petticoats. Both have high button shoes typical of the 1890–1900 fashion period. (Historical Society of Ocean Grove.)

Seven
MEMORIES AND MEMORIALS

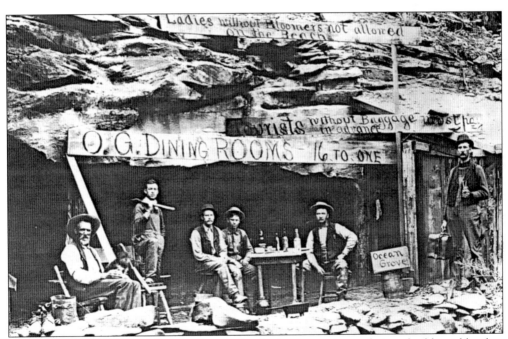

The Ocean Grove Camp Meeting Association had a reputation as being the bluest blue-law town in the nation. This was probably true, but as one Ocean Grove policeman said, "These are the rules, I enforce them, you do not have to come here. We wish you well elsewhere." These gold prospectors on Miguel River near Pinion, Colorado, are having sport at Ocean Grove and some of the regulations. (Courtesy Neptune Museum, Fred Smith Jr., and Denver Public Library, c. 1888.)

Number of arrests	31
" Criminal Warrants issued	4
" Search Warrants	5
Number sent to County Jail	4
" Pack Pedlars put off the ground	8
" " prevented from entering	9
" Other kind of pedlars prevented entering	59
" Rag-pickers put off	43
" Persons stopped with improper bathing clothes	91
" Brought out of the water with improper clothes	17
" Shows on the Beach prevented	2
" Umbrella-menders put off the ground	3
" Organ-grinders put off, and prevented entering	12
" Target-shooting on Beach stopped	5
" Intoxicated persons put off the ground	8
" " Prevented entering	37
" Tramps put off	17
" " prevented entering	31
" Scissors-grinders put off	3
" " prevented entering	8
" Improper persons put off	18
" Brass Bands prevented entering	1
" Improper bill distributors put off	7
" Noisy straw riding parties prevented entering	5
" Lost children returned to parents	27
" Complaints of all kinds attended to	307
" Hacks stopped without license	9
" Grocers "	3
" Oyster and Fish pedlars stopped without license	4
" Beer pedlars put off	2
" Religious frauds put off	2
" Disorderly crowds dispersed	12
" Beggars put off the ground	4
" Hack drivers arrested	1
" Complaints of Hack drivers attended to	7
" Persons prevented from public bathing on the Sabbath	23
" Persons stopped for fast driving	10
" Arrested for fast driving	3
" Dogs arrested	26
" " Destroyed	10
" " Redeemed	16

Camp Meetings always had a history of attracting individuals and groups who would try to heckle or disrupt the peaceful worshipers. The New Jersey charter gave the Ocean Grove Camp Meeting Association the power to police its grounds. In 1880, Police Chief J.C. Patterson presented this list of problems that were handled by Ocean Grove's policemen. Additional efforts included the exclusion of musical bands in the large hotels and boardinghouses as well as the reduction of parlor entertainment. (Historical Society of Ocean Grove.)

Miss E.G. sent this picture postcard to E.B. in Athenia, New Jersey, in 1910. The bathing suit, hat, and laced shoes are the latest fashion for seashore bathing. On the postcard, Miss E.G. asks, "Isn't this a nice little girl?" She ends her note with an admonition: "Be good." (Historical Society of Ocean Grove.)

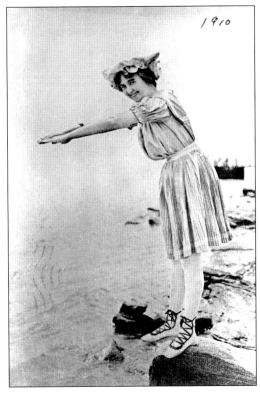

Around 1890, promotional items were used to sell various products. A small silk patch was given with each purchase of a pack of cigarettes. The patches were of different designs, including college names and colors, foreign countries, states, and individual towns. In 1887, the sale of tobacco items in Ocean Grove was punished by a fine of $5 for every offense. A collection of New Jersey coastal town patches included Keansburg, Long Branch, Asbury Park, Ocean Grove, and Atlantic City. The "Ocean Grove Girl," by artist H. King, in her blue swimsuit with yellow trim is now a greatly sought-after collectible.

Reverend Stokes would generally comment and lament on the bathing attire worn by residents going to and from the beach. The *Illustrated Police News*, c. 1890, printed this cartoon character poking fun at the Ocean Grove Camp Meeting Association's enforcement of a bathing dress code.

These girls and some friends pose for a typical slumber party. The young lady in the middle appears to be the devil, who is obviously encouraging the other young ladies to enjoy a good smoke. (Courtesy Historical Society of Ocean Grove.)

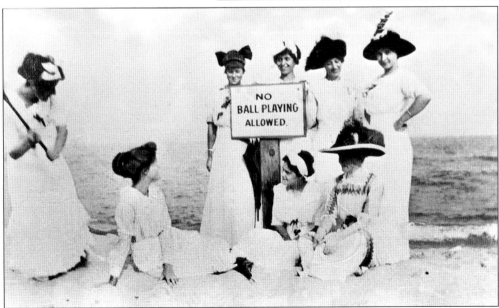

These seven sisters are posing for a ball-playing picture on the beach. Living in the house with seven daughters must have been fun. The laundry is another issue. (Historical Society of Ocean Grove.)

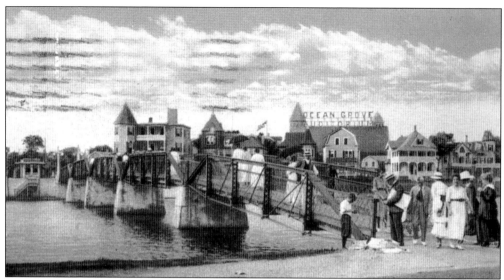

In 1888, an agreement was reached with James Bradley on the construction of two iron bridges to replace the ferries. Terms of the agreement prohibited any stands for carriages, stages, hacks, omnibuses, newspapers, books, "segars" or other types of businesses within one block of the Asbury Park side of the footbridge. Clearly, this picture was not taken on Sunday, as the sale of newspapers was not allowed so close to the bridge. The newspaper boy, if caught, would be punished by a fine of $25.

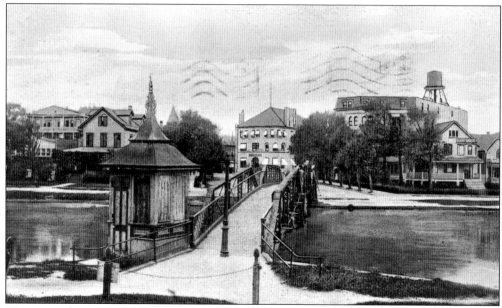

The joint agreement for the two bridges specified that a toll of 1¢ would be charged for the months of June, July, August, and September. The fee was to be collected by a policeman at the tollhouses located on the Ocean Grove side of the bridges. No tolls were charged on Sundays, but a policeman was still on duty to see that no drunken or disorderly people entered Ocean Grove. The total amount of fees collected was evenly divided between Asbury Park and Ocean Grove, but only after operating expenses were deducted. The total of the 1¢ tolls amounted to $3,413.74 in 1889. (Courtesy Judy Ryerson.)

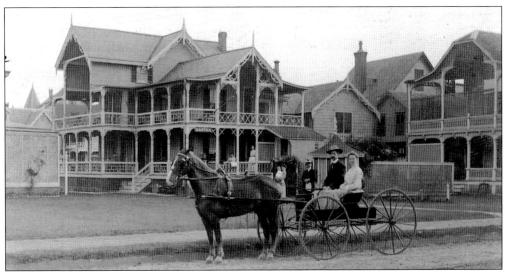

Many summer residents named their cottages. This 1903 photograph shows "Martha," the residence of Mrs. M. Wilhelm, who is dressed in white in the buggy. Mrs. Wilhelm stayed in her cottage from the middle of May to the middle of October. The difference between a cottage and a home is that a cottage was occupied during the summer, while a home was a year-round residence. (Courtesy James Lindemuth.)

The streets of Ocean Grove were constantly being upgraded with sand, clay, and gravel in order to provide ease of transportation. This 1910 Buick Model 16 touring car in front of 69 Mount Hermon Way may be down for a visit to the young couple standing on the porch. The lot was first purchased by William G. Jimson on December 19, 1872. In 1891, this home was sold by the widow Carolyn W. Kleine of Morristown to Andrew K. Rowon of Trenton, New Jersey. (Historical Society of Ocean Grove.)

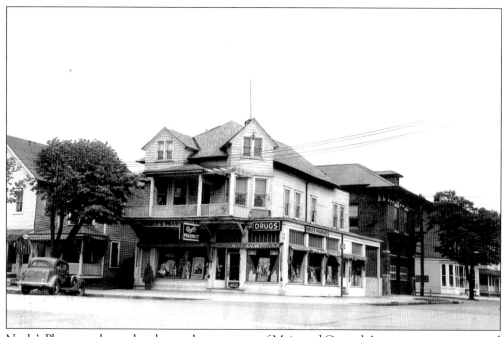

Nagle's Pharmacy, located at the northwest corner of Main and Central Avenues, was a year-round drug store and ice-cream parlor. To the rear along Olin Street are the Washington and Stokes firehouses. In 1887, the Stokes Company voted to prohibit smoking and chewing of tobacco in their meeting rooms. (Courtesy Leonard Steen.)

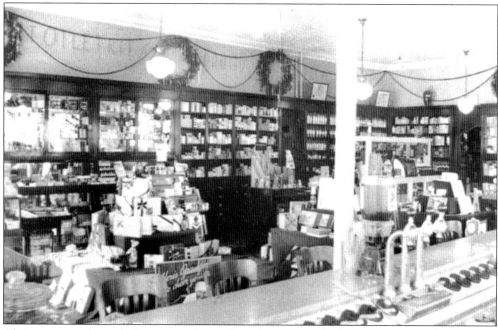

Christmas wreaths and glass swags above the cabinets signify the season, as do the wrapped candy boxes in the center aisles. These photographs were used in the restoration of both the exterior and interior of Nagle's Pharmacy. (Courtesy Leonard Steen.)

The exterior of 64 Main Avenue has not changed since it was built in 1899 by G.W. Evans, the secretary of the Ocean Grove Camp Meeting Association. The sheet-metal facade has been completely restored by its current occupant, Dr. Dale C. Whilden, a dentist. It was previously known as the *Ocean Grove Times* building, where the weekly newspaper was printed and assembled. (Courtesy Dr. Dale C. Whilden.)

Ocean Plaza, formerly the "Inskip House," has been restored and completely remodeled. This is one example of the renaissance that has occurred after this planned community was placed on the State and National Register of Historic Sites. (Courtesy Jack and Valerie Green.)

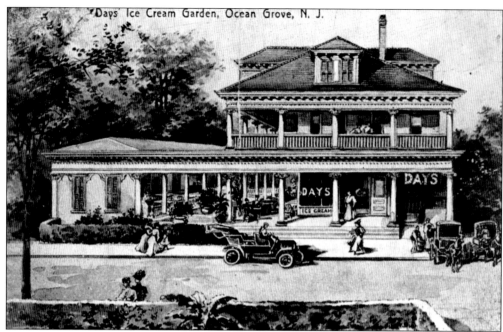

Days' Ice Cream Garden was established in Ocean Grove by Wilbur and Pennington Day in August 1876. The building has an open, roofless court in the center with a carpet of grass and brightly colored flowers, surrounded by tables. F. W. Woolworth would make special trips to Days' to enjoy the different ice cream offerings. One specialty was nesselrode pudding with French chestnuts and orange flower water. (Historical Society of Ocean Grove.)

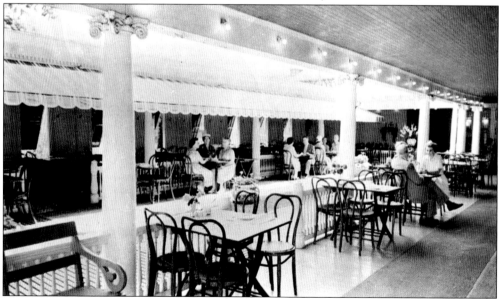

Days' is the oldest continuously operating business at one location in Ocean Grove. Other people who delighted in the cooling ice creams included Max Baer, Mayor Frank Hague of Jersey City, and Nordica and James J. Corbett. The garden has been carefully restored by its current owners, Phil and Karla Herr. The walnut tables and oak bentwoods are original. (Historical Society of Ocean Grove.)

In 1914, Paul J. Strassburger opened his grocery store at the northeast corner of Pilgrim Pathway and Olin Street. It was known for fresh meats, fruits, and vegetables. By 1927, the building had been enlarged to its present three-story stucco facade. The business was purchased by Herbert A. Philson and Thomas Davis in 1946, who changed the name of the store to Pathway Market. Davis's son-in-law, Herman Brown, subsequently purchased the market in 1964. (Courtesy Herman Brown.)

A goat is not what we normally think of as transportation. These three girls are enjoying a brief ride around the block. The young lady in the back with the hair bows is Ethel Donnell. In front of her with the pig tails is her sister, Elva. (Courtesy Eva Cadmus.)

The tradition of a community Christmas tree was started in 1914 in the center of Woodlawn Park, now called Fireman's Park. A large cedar tree was placed and decorated with lights of varied colors and, at the top, a star. Today the tradition continues on Christmas Eve, as Ocean Grove residents gather at 6 p.m. to sing carols with a brass band and have prayers and a greeting. Santa Claus then arrives on a fire truck, bearing brown bags of hard candy, apples, and oranges for each person. The entire park is festooned in colored lights set up by the fire departments. Later in the evening, the firemen deliver bags to all the shut-ins in Ocean Grove. One year, Santa landed in a single-engine plane on Main Avenue. The plane, flown by Ed Brown, taxied to Nagle's Pharmacy, where Santa (James Herbert) emerged to a cheering throng. (Historical Society of Ocean Grove.)

The Fourth of July parade is an annual event that the entire town eagerly awaits. Boy Scouts, Cub Scouts, Girl Scouts, and Brownies all participate. This Boy Scout Troop No. 41 is sponsored by St. Paul's United Methodist Church. Dennis Wood, the scoutmaster, is in the rear. (Courtesy Christopher Wood.)

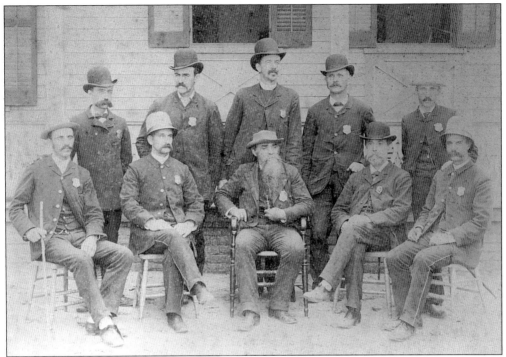

The first chief of police, Maj. J.C. Patterson (lower center) sits in the middle of the ten-member summer police force. Extra guards might be hired for toll collection duties at the bridges from June to September. The list of reported incidences in the annual reports suggests that the police were active in their enforcement of Ocean Grove Camp Meeting Association regulations. (Historical Society of Ocean Grove.)

Dedicated service has always been the purpose of the Methodist Home for the Aged. This facility replaced the original wooden Victorian home at 63 Clark Avenue, which had been destroyed by fire in 1916. The home was expanded in 1919 and 1922. (Courtesy Mary Morgan.)

Ben Douglas saw a need and did something about it. In 1990, his son, who owned a hobby shop, was beaten and robbed. Ben organized the Ocean Grove Citizen's Patrol, a group of residents (now 118 members and growing) who patrol the streets of Ocean Grove at night in vehicles equipped with radios. Any suspicious activity is reported to the Neptune Police Department. The group has received many local and state awards for their annual 14,000 hours of being a successful mobile neighborhood watch. (Courtesy Ben Douglas.)

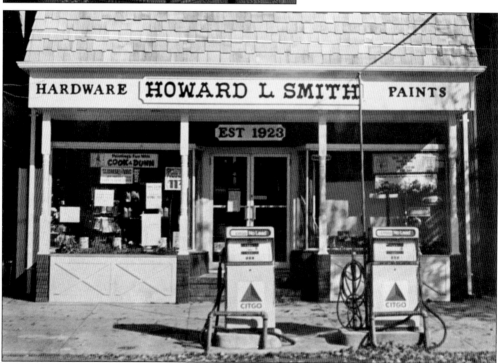

As many people have discovered in Ocean Grove, no room is square or level. Howard Smith Hardware was the only hardware store–gas station in Ocean Grove where one could unravel the mysteries of plumbing and doorjambs. "If the washer doesn't fit, bring it back and try another size," was the management's often-repeated phrase. As was the custom, the store was never open on Sunday. (Courtesy Howard Smith.)

Activities and memorials honoring the past were very important in the social fabric of Ocean Grove. The Bishop Janes Tabernacle honored the bishop who dedicated the Camp Meeting Grounds. Large crowds attended the Fourth of July parade and the reading of the Declaration of Independence in the Auditorium, followed by a patriotic speech. On July 4, 1878, the memorial *Angel of Victory* was dedicated on the beachfront at the foot of Main Avenue in memory of those who died at the Battle of Monmouth in Freehold, New Jersey, in 1778. The angel, facing west, is sitting on a pedestal with upraised wings. A wreath of leaves symbolizing victory is in one hand at her side. The monument was destroyed by a storm in the early 1930s. The Historical Society of Ocean Grove is now raising funds to construct a new *Angel of Victory*. (Historical Society of Ocean Grove.)

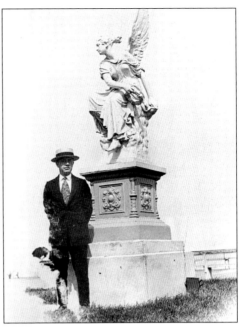

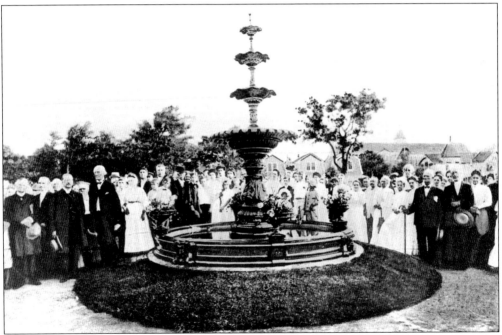

After the death of Reverend Stokes in 1897, Bishop James N. Fitzgerald was elected as the second president of the Ocean Grove Camp Meeting Association. He served in this capacity until his death in 1906 during an evangelistic tour in India. His wife was one of the founders of the Mount Tabor Camp Meeting near Denville, New Jersey. A memorial cast-iron fountain was commissioned in his name at the center of Founders Park. The third president of the association, Rev. Aaron E. Ballard, is to the left. Ballard was also president of the Pitman Grove Camp Meeting in Gloucester County, New Jersey. He died in 1919, the last remaining original Camp Meeting trustee. (Courtesy Ethel Hemphill.)

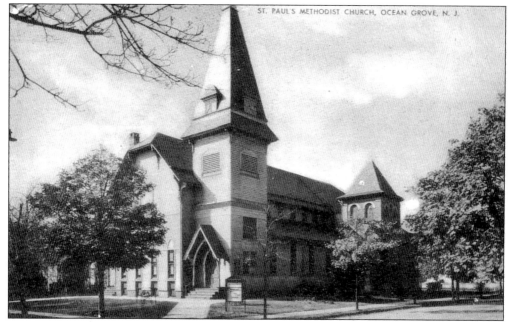

St. Paul's United Methodist Church was built in 1885 at Park Square in Ocean Grove. The congregation had moved from its former location—just south of the Main Avenue gates—when the land was leased to Neptune Township for the site of the new 1896 Neptune High School. In the 1960s, under the leadership of Jim Hendrickson, St. Paul's church underwent major reconstruction. The former Neptune High School is now being restored to be used as a performing arts center. (Historical Society of Ocean Grove.)

On July 31, 1875, a memorial vase was dedicated to the early trustees of the Ocean Grove Camp Meeting Association who had died between 1870 and 1875. This cast-iron urn marks the place where the first candlelight tent prayer service was held in 1869 by Mrs. Joseph H. Thornley. (Historical Society of Ocean Grove.)

The Fireman's Memorial for deceased firemen was dedicated on May 2, 1959, at Woodlawn Park on Main Avenue. The old fire bell, which had tolled fire alarms for over 50 years, was chosen as a suitable memorial. The bell was mounted to a granite base in the center of the park, on a concrete base in the shape of the fireman's Maltese Cross Badge. Granite benches were also installed. The cost of the memorial was paid by public subscription raised by the members of the Ocean Grove Fire Department. Committee members included, from left to right, Byron Holmes, Kinsey Merritt, Joseph Shafto, and Richard Stout. (Courtesy William Schwartz.)

Parks were an important part of the design plan of Ocean Grove. A memorial triangle at the Broadway entrance to Ocean Grove includes a soldier's monument, dedicated in 1917 to all of the Neptune Township men who fought in World War I. A field howitzer at the eastern end of the memorial triangle was replaced in 1947 with four stone columns engraved with the names of those who served in World War II. (Historical Society of Ocean Grove.)

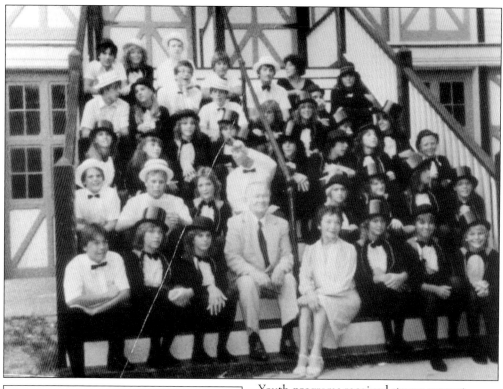

Youth programs received strong support from the Ocean Grove Camp Meeting Association. Tali Esen Morgan, Charles Yatman, Walter Eddowes, and Dexter Davison are some of the adult leaders who gave of their talents to develop youth programs in the Great Auditorium. Dexter Davison and Marjorie Fix, center, are surrounded by a group of top-hatted choristers. "Mr. D's" unofficial policy was that if a child was in Ocean Grove for a one-week vacation and the show was that week, there was always room for one more chipmunk or angel in the cast. (Courtesy Janet Davison.)

The *Spirit of Broadway '76* show poster is typical of the musical reviews presented by the summer youth of Ocean Grove. Rehearsals under the coordination of Reba Weilert were held in the Uncle Bill Thomson Youth Center. (Courtesy Janet Davison.)

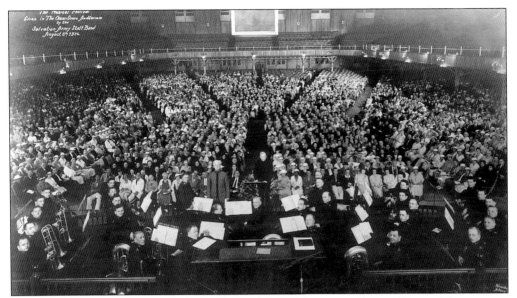

The Salvation Army Staff Band has always been welcome in Ocean Grove. The summer Auditorium program traditionally has one Sunday service led by the Salvation Army. The world leaders of the Salvation Army have preached many times in Ocean Grove. (Historical Society of Ocean Grove.)

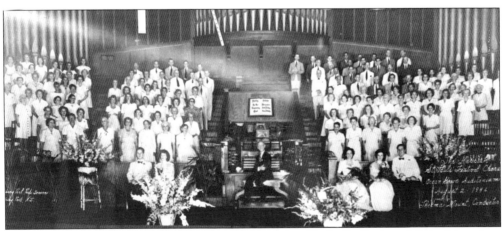

Major religious works, including *The Messiah, Creation, Elijah, St. Paul,* and *Judas Maccabeus* were presented on St. Paul's Night at the Great Auditorium under the direction of Thelma Mount, choirmaster of St. Paul's United Methodist Church. The offering was forwarded to St. Paul's to help close their budget deficit due to members attending Ocean Grove Camp Meeting Association services over the summer. (Courtesy Thelma Rainear.)

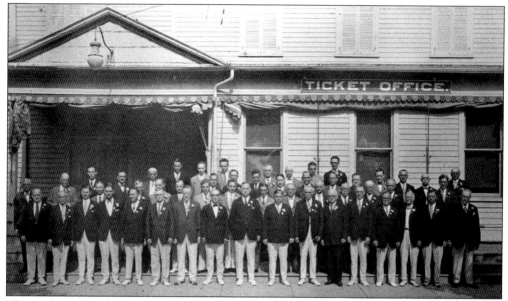

The Auditorium ushers pose prior to Sunday morning worship. The ushers faithfully participate each Sunday as greeters at the doors of the Great Auditorium. Formally organized in 1906, they have been a mainstay of the weekly services. The ushers are strongly supported by the Ladies Auxiliary of the Auditorium Ushers who, with their fund-raising projects, contribute to numerous programs in the community. (Historical Society of Ocean Grove.)

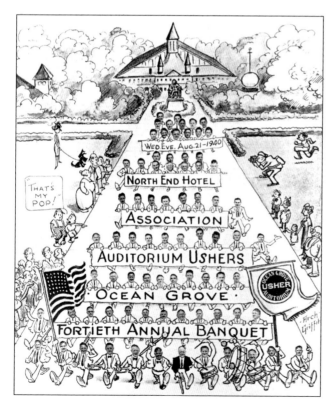

The Auditorium Ushers had two annual events. One was the Ushers Show in the Great Auditorium, and the other was the yearly banquet. This banquet announcement from 1940 was designed by Archie Griffith, a talented local artist. Griffith would draw the card and, using the annual usher's photograph, would place their heads on his cartoon figures. (Historical Society of Ocean Grove.)

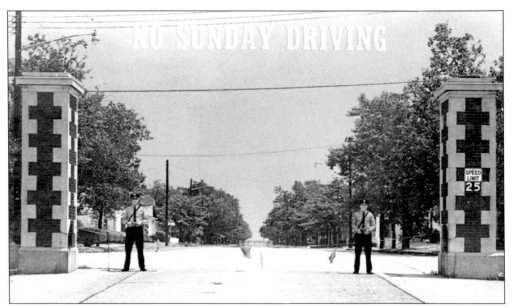

The original Main Avenue gates into Ocean Grove were swinging wooden gates. They were replaced in 1916 by two tapestry brick pillars, each topped by a light. The bronze tablets, one on each side, were inscribed with the following messages: "Enter into His Gates with Thanksgiving" and "And into His Courts with Praise." (Historical Society of Ocean Grove.)

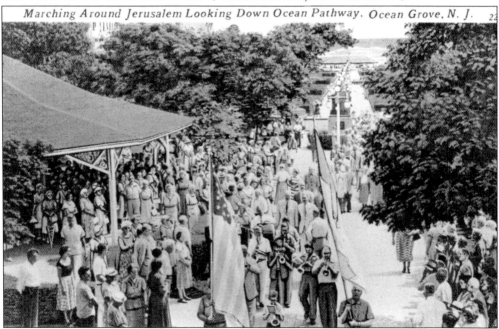

An Ocean Grove tradition at the annual close of Camp Meeting is the march, led by the trustees—with American and Christian flags and drums and bugles—into each of the Ocean Grove Camp Meeting Association's public buildings. In years past, the marchers sang hymns, including "We're Marching to Zion," "Beulah Land," "In the Sweet By-and-By," and "God Be with You Till We Meet Again." These annual traditions help to ensure the permanency of the Ocean Grove Camp Meeting. (Courtesy Judy Ryerson.)

This house at 45 Embury Avenue is for sale, as the sign in the yard indicates. The two porches are in the L-shape style of this 1880–1890 cedar clapboard single-family home. The two-over-two windows without screens are open from both the top and bottom, thereby allowing the maximum circulation of air throughout the house. The swagged picket fence, porch balustrades, and the pent are typical features. It was in this house that Syngman Rhee, later president of South Korea, spent the Christmas holidays in 1908 as a guest of Prof. O.G.J. Schadt. (Courtesy A. H. Watson.)

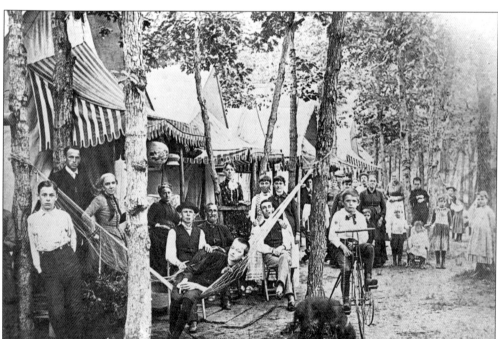

Arthur C. Smith moved with his family to Ocean Grove from Philadelphia in 1890. His son, Frederick A. Smith, stands at the left in the fork of the tree. (Courtesy Frederick A. Smith, Jr.)

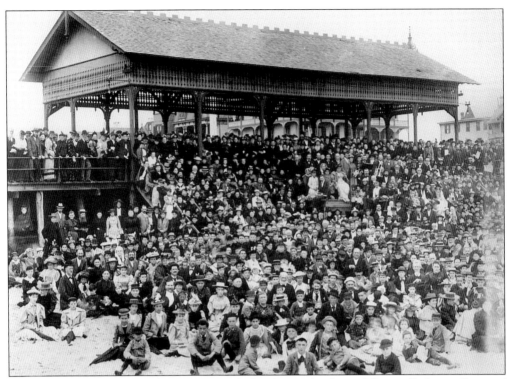

A surfside meeting was held at 6 p.m. each Sunday at the foot of Ocean Pathway. Songs of praise and a short sermon inspired the crowd of worshipers, numbering between two and five thousand as they stood or sat in a wide natural amphitheater below the pavilion. Dr. Stokes can be found to the right center. The fourth person to the left of the lady in white, seated center, appears to be Amanda Berry Smith, an Ocean Grove favorite.

This sign says it all as you leave the State and National Historic District of Ocean Grove.

BIBLIOGRAPHY

Beers, F.W. *1873 Atlas of the Jersey Shore*. New York, NY.
Brewer, R.G. *Perspectives on Ocean Grove*. Ocean Grove, NJ: Historical Society of Ocean Grove, 1969.
Cole, E.N. *Ocean Grove, New Jersey*. 1911.
Daniels, M.S. *Story of Ocean Grove*. New York: The Methodist Book Concern, 1919.
Gibbons, R.F. and F. Gibbons. *History of Ocean Grove, 1869–1939*. Ocean Grove, NJ: Ocean Grove Times, 1939.
Goodrich, Peggy. *Four Score and Five: History of the Township of Neptune*. 1976.
History of Ocean Grove, New Jersey, 1869–1944. Ocean Grove, NJ: Ocean Grove Camp Meeting Association, 1944.
Jones, C.E. *Perfectionist Persuasion: the Holiness Movement and American Methodism, 1867–1936*. Metuchen, NJ: Scarecrow Press, 1974.
Messenger, Troy. *Holy Leisure*. University of Minnesota Press, 1999.
Ocean Grove Camp Meeting Association. Annual Reports, 1870–1919. Ocean Grove, NJ.
Osborn, W.B. *Pioneer Days of Ocean Grove*. The Methodist Book Concern, NY.
Ocean Grove Camp Meeting Association, 1914–1918. *Ocean Grove Monthly*. Ocean Grove, NJ.
Pfaltz, Marilyn and A. Reed. *Ocean Grove: God's Square Mile*. Summit, NJ: P&R Associates, 1986.
Shaw, John R. and G. Hoffmeier. *The Great Auditorium Organ*. Ocean Grove, NJ: Ocean Grove Camp Meeting Association, 1995.
Sweet, W.W. *Methodism in American History*. New York: The Methodist Book Concern, 1933.
Wolman and Rose. *Atlas of Monmouth County*. Philadelphia, PA. 1878.